HALLOWED TIMBERS

The Wooden Churches of Cape Breton

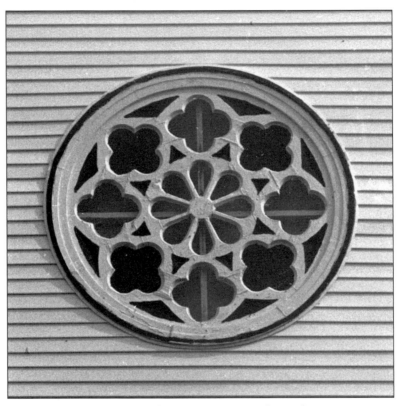

St. Margaret's, Broad Cove, rosette window, plate tracery
Right: Princeville United

HALLOWED TIMBERS

The Wooden Churches of Cape Breton

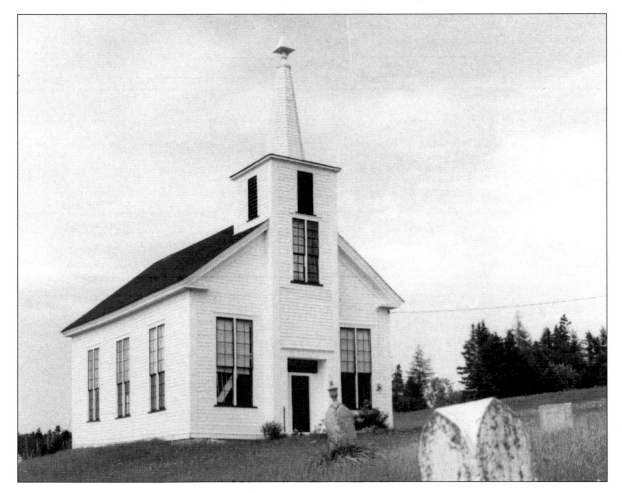

SUSAN HYDE & MICHAEL BIRD

A BOSTON MILLS PRESS BOOK

Stoddart

Canadian Cataloguing in Publication Data

Hyde, Susan Ann, 1953–
Hallowed timbers : the wooden churches of
Cape Breton
ISBN 1–55046–121–4

1. Church architecture – Nova Scotia – Cape
Breton Island. 2. Building, Wooden – Nova
Scotia – Cape Breton Island.
3. Churches – Nova Scotia –
Cape Breton Island.
I. Bird, Michael S., 1941– . II. Title

NA5246.C36H9 1995 726'.5'097169
C95–930508–4

© 1995 Susan A. Hyde and Michael S. Bird
Design and Typography by Daniel Crack,
Kinetics Design & Illustration
Printed in Canada

First published in 1995 by
Stoddart Publishing Co. Limited
34 Lesmill Road
Toronto, Canada M3B 2T6

A BOSTON MILLS PRESS BOOK
The Boston Mills Press
132 Main Street
Erin, Ontario N0B 1T0

The publisher gratefully acknowledges the
support of the Canada Council, Ontario
Ministry of Culture and Communications,
Ontario Arts Council and Ontario Publishing
Centre in the development of writing and
publishing in Canada.

ACKNOWLEDGMENTS

WE WOULD LIKE TO ACKNOWLEDGE the extraordinary help given to us by staff at the Beaton Institute, notably Diane Chisholm, Kate Currie, MaryKay MacLeod, Dr. Robert Morgan, Doug MacPhee and Louis Ross. Ron Caplan has been a good friend and generous supporter at every stage. Dr. Jim St. Clair has opened many a door (figuratively and literally) and provided a thoughtful foreword.

TABLE OF CONTENTS

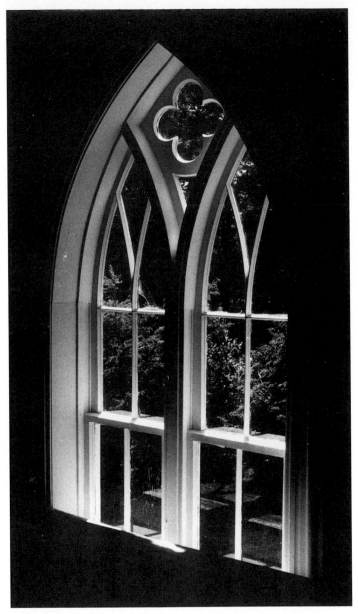

Immaculate Conception, West Lake Ainslie, Gothic

FOREWORD

A MACDONALD POET of the early nineteenth century, separated by time and space from his beloved Cape Breton Island, wrote in Gaelic, *Chi mi bhuam, fada bhuam…Ceap Breatuinn, mo luaidh* (I see far, far away…Cape Breton, my love). That same intense regard for the small island in the Gulf of St. Lawrence may also be found in the work of Susan Hyde and Michael Bird. Although "from away," they reveal an affection for the church buildings and for Cape Breton as deep as that of long-time residents. So, even though readers may be "far, far away," they will nevertheless be brought into a personal relationship with the hallowed timbers of the island. And many may be enticed to travel the highways and byroads to see, touch and enjoy these churches in person.

The buildings of Cape Breton are much like people—they have personalities of their own. As a child, I was surprised by the way in which visiting relatives and friends asked about each other's houses and barns: How had they wintered and how were their foundations? It was as though people were asking after beloved relatives. Ever since, I have cherished the work of old-time builders and wept at the losses that fire and bulldozers have brought. One of my most lamented lost loves is a church that cannot be in this book, since it succumbed to a careless spark over thirty years ago. The MacLean Church at Stewartdale, near Whycocomagh, had features so like many of the churches portrayed in this book—panes of clear glass, Gothic windows, box pews, a square blunt tower with a painted clock. Six generations of my family attended services in it; it was a member of our extended kith and kin. And I renew my friendship with it through reminiscences inspired by buildings in this book. These sanctuaries are much like dear friends.

For a long time Cape Bretoners have valued a building well-positioned on a site—"a good stand" is the phrase generally used. Many of the churches described in this volume are on "a good stand," whether alone on a mountaintop, as is St. Margaret's Roman Catholic Church on River Denys Mountain, or close to a busy highway, like Ephraim

Scott Memorial in St. Anns. As well as placing the churches in a geographical location, the background material and photographs assist the reader in understanding the cultural and historical setting; this book provides "a good stand."

The avid church-gazer may journey around Cape Breton with this book as a guide. And the armchair reader also will come to appreciate the character of Cape Breton Island. The people of this island have been remarkable for their creative energy, in architecture, in music, in hooked rugs, quilts and poetry. The cherished places of worship found in this book are significant elements of the visual and emotional mosaic that is the heart of Cape Breton's continuing story.

This book encourages us all, wherever we live, to be more deeply sensitive to the history, beauty and spiritual significance of hallowed timbers. I am grateful to the authors for their perceptive eyes. By their shared respect for these beloved buildings the authors have increased our capacity to see and to enjoy, and, especially, to cherish these treasures in our midst.

PROFESSOR JIM ST. CLAIR
MULL RIVER, MABOU, NOVA SCOTIA

PREFACE

AMONG the many enticements that led me across the country to the Atlantic coast were two striking mental images: the charming fishing villages and the picturesque wooden churches of Cape Breton. Cape Breton Island is extraordinarily beautiful in countless respects, and it is against this spectacular backdrop of mountain, river and sea that its many country churches command their timeless appeal. From the time of my arrival, I took great pleasure in photographing these unique places of worship, and it was an unexpected joy to find a similarly avid enthusiast in Michael Bird, who joined me in this project in the summer of 1990.

In appreciation of the kindness shown me during my time in this beautiful part of Canada, and as a token of respect and admiration for the early settlers and their descendants in Cape Breton, I dedicate this photographic essay to those special people and the place that served as my home for those rich years. It is my hope that this book of photographs and commentary will make residents and visitors alike more aware of the special charm of these fascinating sacred places.

SUSAN HYDE, 1995

I am thrilled to share Susan's enthusiasm and desire to make a photographic tribute to this particular achievement of Cape Breton's determined settlers. The resourcefulness of those who built and used these wooden houses of worship is truly remarkable, and the structures we see today are a wondrous visible record of building ingenuity and spiritual commitment.

I was immediately attracted to this undertaking when I learned of Susan's wish to create this tribute as an expression of her appreciation to the people of Cape Breton Island. Like Susan, I hope that as people travel around the Island to enjoy its natural attractions they will also take advantage of the opportunity to savour the unique beauty of its wooden churches.

MICHAEL BIRD, 1995

St. Andrew's Presbyterian, North River, steeple with geometric design

INTRODUCTION

CAPE BRETON ISLAND is a densely wooded land. From the heights of its mountains to the low-lying coastal regions sloping away on all sides, the Island appears from above as a lush carpet of deep green in summer, intense red and gold in autumn. Rarely are towns large enough or fields sufficiently expansive to push back the rich forestation. Only the abundant lakes and rivers have that power.

With a seemingly inexhaustible stand of timber, it is not surprising that the buildings of Cape Breton were constructed primarily of wood. The number of pre-1900 churches built of stone or brick make up but a tiny fraction of the religious architecture of the Island. To be certain, one of the best-known of Island places of worship is the commodious stone church of St. Peter's at Cheticamp. A handful of other stone churches can be counted—old St. Patrick's (1829) and St. George's Anglican (1787) in Sydney, and St. Andrew's at Judique (1924). Brick structures are similarily few and far between—St. Columba's at Iona, and St. Peter's at Port Hood. The stone church at Judique is beautiful in its smallness of scale and simple carved decoration; the immense structure at Cheticamp resembles many nineteenth-century stone churches built throughout Québec; the brick churches at Iona and Port Hood are similar to late nineteenth-century counterparts found all over the United States and Canada.

The wooden churches of Cape Breton—and there are many of them—define the distinctive ecclesiastical architecture of the place in a way the brick and stone structures fail to do. Although these places of worship constructed of native timber bear resemblances to others built on the Nova Scotia mainland and elsewhere in the Atlantic region, they are markedly different. Taken collectively, Cape Breton wooden churches are not easily confused with those constructed in neighbouring provinces.

The surprisingly ingenuous combinations of design elements and architectural styles serve to illustrate a dynamic process of hybridization and adaptation. Perhaps it is true that the various nineteenth-century "revivals" were in most regions and instances amalgamations rather than consistent perpetuations of pure styles; that is especially the case with the wooden churches that mark countless turns and crossroads from Port Hastings to Cape North.

The chronological span of churches covered in the present journey is just over a century, from the 1837 Church of L'Assomption at Arichat to the 1939 Church of John the Baptist at Brook Village. Fire has been the great enemy of wooden churches, with many early examples damaged or completely razed. Water has done its part, too. The congregation of Knox Presbyterian at Ross Ferry in recent years found that rotting caused by moisture in the floor precluded the use of their church for a brief time. The vulnerability of wooden structures to the destructive forces of nature has meant the loss of many examples, hence obscuring a more accurate visual record of early Cape Breton religious architecture.

Among the churches examined in these pages, several of the principal examples fall within the following time periods. Dates are approximate; in some cases churches were begun in one year and completed in a later year (the date of completion is used here). Some churches listed as Presbyterian are now United Church of Canada, following reorganization in 1925. Because of the large number of Roman Catholic churches, they are listed by name only; Protestant churches are listed by name and denomination.

1830 ~ 1840		1880 ~ 1890	
1837	L'Assomption, Arichat	c. 1880	Stella Maris, Creignish
1840 ~ 1850		1881	St. David's United, Port Hastings
1841	St. Margaret's, River Denys Mountain	1883	St. Peter and St. John Anglican, Baddeck
1841	St. Mary's, East Bay	1887	St. Francis de Sales, River Inhabitants
1850 ~ 1860		1887	Knox Presbyterian, Ross Ferry
1850	St. Columba United, Leitches Creek	1888	Mabou-Hillsborough Presbyterian, Hillsboro
1853	St. Margaret's, Broad Cove	**1890 ~ 1900**	
1858	St. Mary's, Frenchvale	1890	Greenwood United, Baddeck
1858–60	St. Michael's, Baddeck	1891	St. Rose of Lima, Northside East Bay
1860 ~ 1870		1891	St. Peter's Presbyterian, Neils Harbour
1864	Princeville United	1891	Grand River Presbyterian
1865	St. Andrew's Presbyterian, Forks Baddeck	1892	St. Mary's, Big Pond
1869	St. John the Baptist, River Bourgeois	1893	St. Mark's Presbyterian, Englishtown
1870 ~ 1880		1893	Stewart Presbyterian, Whycocomagh
1871	St. Patrick's, North East Margaree	1895	Strathlorne Presbyterian
1872–73	Immaculate Conception, West Lake Ainslie	1897	St. Mary's, Mabou
1873	St. Margaret's, Grand Mira	1898	St. Dionysius, River Denys Station
1874	Malagawatch United	1898	Calvin Presbyterian, Birch Plain
1874	Cleveland Presbyterian	**1900 ~ 1910**	
1873	St. Joseph's, Glencoe Mills	1907	Chalmer's United, Groves Point
1873	St. Andrew's Presbyterian, North River	1909	St. Andrew's Presbyterian, Framboise
1875	First Presbyterian, Cape North	**1910 ~ 1920**	
1876–77	St. Mary's and All Angels, Glendale	1912	St. Joseph's, Petit-de-Grat
1877	St. Bartholomew's Anglican, Louisbourg	1915	St. Margaret's, St. Margaret Village
1877	Farquharson Memorial Presbyterian, Middle River	**1920 ~ 1930**	
		1925	Middle River United
		1926	Bethel United, Skir Dhu
		1926–27	Glen Valley United
		1929	Mabou Pioneer Shrine, Mabou
		1930 ~ 1940	
1879	St. Joachim, South Side Boularderie	1939	St. John the Baptist, Brook Village

From within this particular grouping, the largest number of churches were constructed in the period from about 1860 to 1900. This time frame coincides with the steady congregational growth of the latter part of the nineteenth century in Cape Breton, as well as with modest improvement in economic conditions and with concerted evangelical efforts within Presbyterian, Baptist and Methodist groups that resulted in a growing number of congregations and expanded building activity. While many of the churches erected by Roman Catholic and Protestant congregations were humble efforts, this was also the time at which several more ambitious projects were undertaken, culminating in such large Catholic churches as St. Patrick's in North East Margaree and St. Mary's in Mabou, and the commodious Presbyterian churches in Baddeck (Greenwood United), Middle River (Farquharson Memorial) and Ross Ferry (Knox Presbyterian). One of the largest churches—also the most remote—is St. Andrew's Presbyterian, constructed far from paved highways along the east side of Loch Lomond in 1912.

Interestingly enough, there is little correlation between architectural style and date of construction in Cape Breton's wooden churches. The usual chronology of nineteenth-century architectural styles begins with neoclassical (Greek revival), followed by Gothic revival, with other variations occurring along the way. In the case of Cape Breton churches, however, there is little evidence of such a neat evolution. One might consider several structures and their dates: the Gothic-revival churches of St. Margaret's, Broad Cove, and St. Mary's, Frenchvale, were built in 1853 and 1858 respectively; three Greek-revival churches at Princeville, Forks Baddeck and Malagawatch were constructed at later dates (1864, 1865 and 1874), to be followed by still later neo-Gothic churches built throughout the Island in the 1880s and 1890s. Indeed, the overwhelmingly preferred style was that of the Gothic revival, with only occasional examples of other forms found on the Island. The situation with respect to domestic architecture is somewhat different. Many styles were employed in house-building, including plain Georgian, neoclassical, Scottish vernacular (with characteristic five-sided dormers), Irish cottage, Gothic revival, Victorian, Italianate, and Edwardian.

It is important to note that Cape Breton has a long and complex cultural history, and that both French- and English-language groups make up its population. Our survey of wooden churches includes some examples constructed within the French communi-

ties on or near Isle Madame, notably at Arichat, Petit-de-Grat, River Bourgeois, Louis-dale and River Inhabitants. The architecture of these places of worship is, however, largely indistinguishable from that found in the areas settled by American Loyalists, Highland Scots, and Irish. Only the few fleur-de-lis motifs within the Church of Francis de Sales at River Inhabitants offer evidence of French influence. "French" architecture on the Island tends to be preserved in stone, not wood, as in the large church of St. Peter's at Cheticamp, a structure modelled closely on nineteenth-century Québec types. A few French ghosts may still linger in the forests of other regions of Cape Breton, especially in areas associated with Nicholas Denys, a French entrepreneur who had arrived much earlier in Cape Breton (Isle Royale), when it was ceded to France by the Treaty of Saint Germaine in 1652. However, at the time of the construction of most surviving wooden churches, the language was no longer French; the predominant tongue was English in Loyalist areas and Gaelic on River Denys Mountain.

The neo-Gothic form is so pervasive in Cape Breton ecclesiastical architecture that it transcends not only the style of the time but also denominational outlook. The popularity of this style, with a central square tower topped by an octagonal or round spire (hearkening back to the church designs of Christopher Wren and James Gibbs), was widespread in both Protestant and Roman Catholic regions of the Island. Certain districts of Richmond and Cape Breton Counties are largely Roman Catholic or a mixture of Catholic and Protestant, while Victoria County is mainly Protestant (Presbyterian and United). Inverness County has a relatively balanced proportion of the two groups. Roman Catholics and Protestants alike found the style appealing, and Gothic-revival structures abound in each of the four counties.

One cannot easily determine the denomination of a Cape Breton place of worship from afar. In the case of Roman Catholic churches, little information comes from the architecture, but is provided rather by the presence of a cross on the top of the spire. Where Roman Catholics placed crosses, Protestants tended to use finials or nothing at all. In a few instances, some rather elaborate finials can provide initial confusion, looking at first glance like crosses. Notable examples of such finials crown the towers or spires of Protestant churches such as Stewart United at Whycocomagh, Ephraim Scott Memorial at South Gut, St. Anns, and St. Columba United at Leitches Creek.

Georgian Meeting House or Hall

THE MEETING-HOUSE type has no full-fledged expression in Cape Breton and is represented only by hints of the form. The meeting-house style is more fully realized in earlier areas of Loyalist or pre-Loyalist settlement on the mainland of Nova Scotia, as in the Barrington Meeting House on the South Shore or the Covenanters' Church at Grand Pré.

In Cape Breton, vestiges of the meeting-house type are alluded to in the large, rectangular, two-storey height of St. Mary's Church at East Bay (1841) and Union Presbyterian at Albert Bridge (1857). The presence of Gothic windows at both churches obscures the plain, rectilinear geometry of the buildings themselves, but their considerable height and boxlike format hark back to the structure of the New England meeting house. The style is more apparent at Union Presbyterian, which has its central canopied pulpit and box pews still intact.

Neoclassical

WHILE MANY CHURCHES possess some neoclassical detailing, particularly in the form of the convention of eave returns, only a handful of structures are primarily of neoclassical, Greek-revival inspiration. These churches are modestly conceived, without the massive columned porticoes found in the impressive example of St. Andrew's Presbyterian at Niagara-on-the-Lake, Ontario, and in some New England churches.

Three of the churches built in the neoclassical style are (or were, before Church Union in 1925) Presbyterian. The fourth is a rare Roman Catholic example, at South Side Boularderie Island.

The three Protestant examples are close together not only in style but also in date. This grouping is comprised of Princeville United (originally Presbyterian, 1864), Malagawatch United (originally Presbyterian, 1874) and St. Andrew's United, Forks Baddeck (originally Presbyterian, 1865). The churches are similarly conceived, with

simple pilasters and returned eaves imparting a temple-like appearance to the front facade. The allusion is strengthened by the placement of a lintel and architrave over the doorways at Princeville and Forks Baddeck, and even more significantly, by a triangular pediment over the entrance at Malagawatch.

The neoclassical treatment of St. Joachim Church at South Side Boularderie is also interesting, if less pronounced. Like these three Protestant "temples," St. Joachim has returned eaves. Although the door is plain, lintels are placed over front and side windows. Further, the squarish severity of the Greek-revival format is emphasized by rectilinear windows whose unusual height echoes those at Princeville, Malagawatch and Forks Baddeck. The octagonal spire of St. Joachim is, of course, of Gothic inspiration, but the square tower, like that at the three Protestant churches, retains the solid, stable manner of the neoclassical taste. When constructed in 1879, this little church may have been inspired in part by design elements of these three Protestant places of worship built during the preceding thirteen years.

St. Joachim was administered from time to time by the parish of Boisdale, whose original wooden church (c. 1860) stood directly across the water, and this early structure may have been yet another design source.

Romanesque

THE ROMANESQUE STYLE gained greater acceptance in early nineteenth-century Roman Catholic architecture, but by the end of the century, the sweeping popularity of that style, especially through the work of American designer Henry Hobson Richardson, meant that the Romanesque was to become an almost universal characteristic of North American buildings—religious, public and domestic alike.

The historical Romanesque style, preceding that of the Gothic, flourished in the tenth and eleventh centuries. Among its recognizable features is the use of the round arch for galleries, arcading, windows and portals. The term "Romanesque" comes partly from the continuing use of the round arch, as favoured by Roman builders in the construction of public buildings, bridges and viaducts, of which many examples survived through early Christian times and even to the present day.

Malagawatch United,
neoclassical

Big Intervale Church,
neoclassical

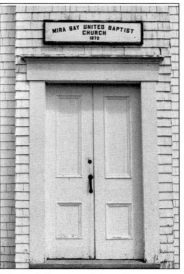

United Baptist, Mira Bay,
neoclassical

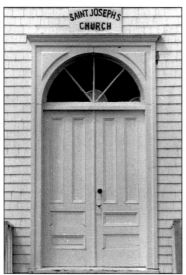

St. Joseph's, Marble Mountain
Romanesque

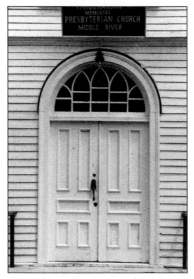

Farquharson Memorial,
Middle River, Romanesque

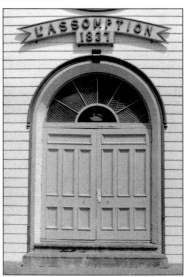

L'Assomption, Arichat,
Renaissance

The Romanesque form gained only a modest foothold in the thinking of Cape Breton church-builders. The round arch is in itself not unusual in nineteenth-century ecclesiastical structures, but occurs rarely as a focal emphasis in the design of Cape Breton religious buildings.

The most conspiciously Romanesque-influenced (there are no Romanesque structures per se) churches are St. Michael's in Baddeck, St. Margaret's at West Bay Road, and Stella Maris at Creignish. In all three churches, windows and doorways are of the round-headed type, with upper ends defined by semicircular framing. The curvature of the arch over the doorway at St. Michael's is somewhat flattened in comparison to that at the other churches, and a neoclassical element has been introduced here by the gabled porch. Faintly Romanesque traces can be found in the fenestration of later churches such as First Presbyterian, Cape North, and Calvin Presbyterian, Loch Lomond.

Renaissance Revival

THE ITALIAN RENAISSANCE of the fifteenth and sixteenth centuries was a time of intellectual rebirth based upon a reconstruction of the greatest ideas, art and architecture of ancient Greece and Rome. Church buildings now assumed grand proportions and sumptuous detailing. All five classical architectural orders were introduced into the construction of columned porches, arcades and altars, and elaborate mouldings and sculptural detail enriched facades inside and out.

While one would not expect such a luxuriant style to have a place in the modest countryside churches of Cape Breton, allusions to such grand architectural forms do occur. Notable examples, constructed more than a century apart, are the churches of L'Assomption at Arichat (1837) and St. John the Baptist at Brook Village (1939). While the round-headed windows at L'Assomption are of Romanesque inspiration, a more majestic Renaissance appearance is conveyed by the embellishment of the west facade by an enormous pedimented porch comprised of a gable supported on deeply fluted square pilasters. Further enrichment is accomplished by complex mouldings on the gable and column plinths and capitals, as well as by heavy dentils beneath the eave returns.

The much smaller Church of St. John the Baptist at Brook Village also shows Romanesque influences in its round-arched windows, but a Renaissance theme is there, too. Even more pronounced than the applied architectural detailing on the facade of L'Assomption is the columned porch at St. John the Baptist. An imposing entrance is established by a triangular pedimented roof extending forward from the door enclosure, supported at the front on two robust, tapered and fluted free-standing columns with fully scrolled Ionic capitals. Even more strongly developed than those at L'Assomption are the elaborate mouldings of the triangular pediment and the rows of dentils along the architrave and within the pediment itself.

Monumental Gothic

WHILE THE GOTHIC REVIVAL is in evidence in perhaps ninety percent of Cape Breton churches, the general rule is one of simplicity (a single tower and a few pointed-arch windows). However, St. Joseph's Church, Little Bras d'Or (Georges River), an already large structure, is made particularly impressive by the placement of two large, square towers flanking the portals of the west facade. Above the triple-door entry is set a large circular window that calls to mind the traditional west rose window of the great French Gothic cathedrals. Seen from a distance, St. Joseph's at Georges River offers a reminder, if a bit rustic, of the glory of Notre Dame in Paris or Notre Dame in Rheims.

Gothic

THE WORD "GOTHIC" was originally a term of derision, reputedly coined by the artist and historian Vasari to describe the rustic attitudes and achievements of uncivilized northern European tribes. As an architectural phenomenon, the Gothic was characterized by emphasis on the vertical, in keeping with medieval theology and mystical thought. Gothic buildings are tall or fitted with towers, spires and pointed-arch doors and windows to give emphasis to height. The enormity of window space and the sheer verticality of structures required external buttresses for support of walls, and their design contributed to the upwardly soaring appearance of Gothic structures generally.

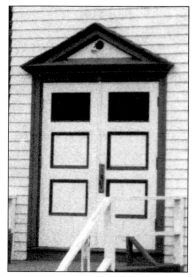

Incarnation, Edwardsville,
Renaissance

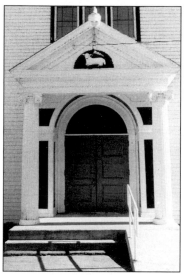

St. John the Baptist,
Brook Village, Renaissance

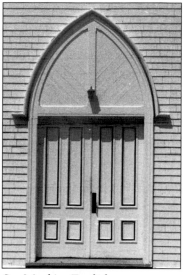

St. Mark's, Englishtown,
Gothic

St. Margaret's, Grand Mira,
Tudor Gothic

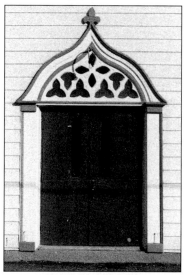

St. Patrick's, North East
Margaree, Tudor Gothic

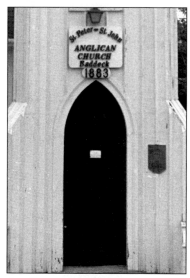

St. Peter and St. John,
Baddeck, Picturesque Gothic

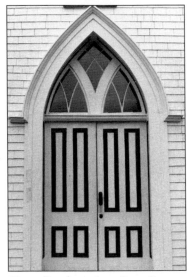

Knox Presbyterian, Ross Ferry, Gothic

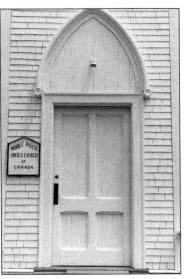

Middle River United, Gothic

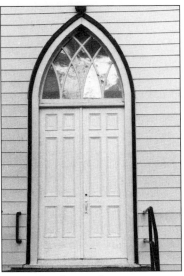

St. Columba Presbyterian, Marion Bridge, Gothic

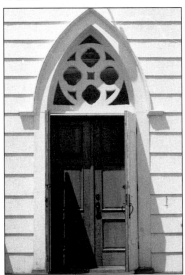

St. James Presbyterian, Big Bras d'Or, Gothic, plate tracery

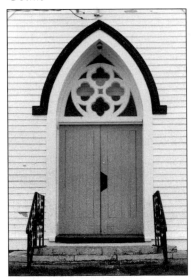

St. Joseph's, Glencoe Mills, Gothic, plate tracery

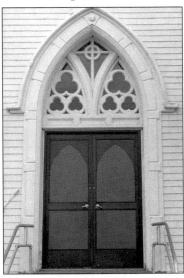

St. Mary's, Mabou, Gothic, plate tracery

The revival of the Gothic style was championed in Europe, especially in France and England, as a return to the "true Christian spirituality" of the medieval world. The style was championed in England by John Ruskin and in August Welby Northmore Pugin's 1841 publication, *The True Principles of Pointed or Christian Architecture*. In Canada, the style was given legitimacy with the construction of Notre Dame Cathedral in Montréal (designed by James O'Donnell and completed in 1829) in the Gothic manner. This single event was of considerable importance in the perpetuation of Gothic-revival design in Catholic architecture across Eastern Canada. It was also the preferred mid-nineteenth-century style of Protestant church builders, and in Cape Breton comprised the lion's share of religious structures built there. Perhaps, as claimed by H.M. Scott with regard to churches in Prince Edward Island, the Gothic revival more truly provided nineteenth-century North Americans with a picturesque reflection of their northern European cultural tradition (*The Historic Churches of Prince Edward Island*, p. 20), and, in the case of the settlers of Cape Breton, of places of worship in Ireland and Scotland. There are so many neo-Gothic examples on the Island that few escape inclusion within the category. Among particularly fine examples of Gothic-revival religious architecture in Cape Breton are St. Margaret's, Broad Cove (1853); St. Mary's, Frenchvale (1858); St. Patrick's, North East Margaree (1871); Immaculate Conception, West Lake Ainslie (c. 1872/3); Knox Presbyterian, Ross Ferry (1887); St. James Presbyterian, Big Bras d'Or (1880s); Greenwood United, Baddeck (1890); and St. Mary's, Mabou (1897).

Picturesque

THE INFLUENCE of North American designers was felt particularly in the small towns and country settings where simplicity of design and economy of material were primary considerations. It was for these congregations that church designs were taken from such writers as Richard Upjohn and Andrew Jackson Downing. In their publications were found illustrations of those many wooden, "board-and-batten" churches that came to be called "Picturesque." Employing Gothic-revival ideas, but simplified so as to be within the competence of local carpenters, these small

yet beautiful churches were built across the United States and Canada after the middle of the nineteenth century. An important feature of Picturesque architecture is the emphasis upon asymmetrical design, with off-centre placement of towers, windows and doors. In Cape Breton, the Picturesque style is represented primarily in Anglican church building. Notable examples include Christ Church Anglican at South Head, St. John Anglican, Arichat, and, most charming, the late nineteenth-century Anglican Church of St. Peter and St. John in Baddeck.

Corner Style

ALSO KNOWN AS THE "AKRON PLAN," the corner-style church gained popularity with Methodists, Baptists and Presbyterians in the last quarter of the nineteenth century. Following the design of a church constructed in the Ohio city of that name, the Akron plan moved the church entry to one or both corners, creating greater flexibility in the use of interior space. Some churches, such as St. Mark's Presbyterian in Englishtown, were simply modified from an earlier Gothic framework. The usual alternative was the construction of a new church, with a corner tower and doorway. Notable Cape Breton corner churches include Glen Valley United, Middle River United, and Bethel United at Skir Dhu. Another example, not illustrated, is St. Matthew's United in Inverness.

Richardsonian Romanesque

THE ROMANESQUE had yet another another North American revival, particularly through the work of the American architect Henry Hobson Richardson (1838–86). In the late nineteenth century he designed many city halls and other public buildings, as well as churches and even homes. The use of round-headed windows and "castle" elements (turrets, crenellation, bays, towers) earned for these distinctive structures the name "Richardsonian Romanesque." While the design is more suitable for urban building, a few country churches exhibit awareness of the style. An interesting example with round-arched windows and circular towerlets is Drummond Memorial United Church on Boularderie Island.

The natural settings of churches throughout the countryside and small villages of Cape Breton gives these sacred places a unique spirit. With their lofty towers and spires, these houses of worship point to the heavens, but with their unblocked window views (stained glass is seldom used), the connection with water and forest surroundings is just as evident. Perhaps it is the mingling of the sense of the transcendent with a reverence for nature that defines the unique appeal of Cape Breton's wooden churches. Few have elaborate decorative detail, bargeboard is uncommon, and tracery is rudimentary in form. The most genuine form of tracery may well be the unfolding of maples and other native trees that surround these churches. Perhaps the deepest spiritual dimension of these hallowed timbers is found in the integration of natural beauty with the aesthetic of modest but ingenuous architectural forms.

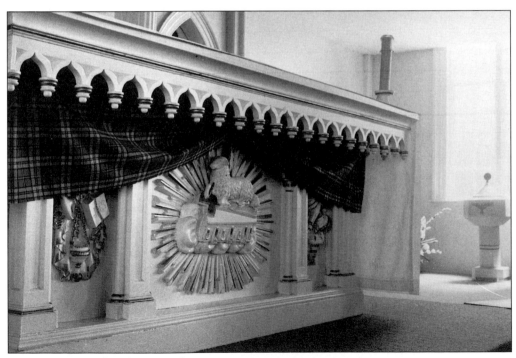

St. Margaret's, Broad Cove, altar

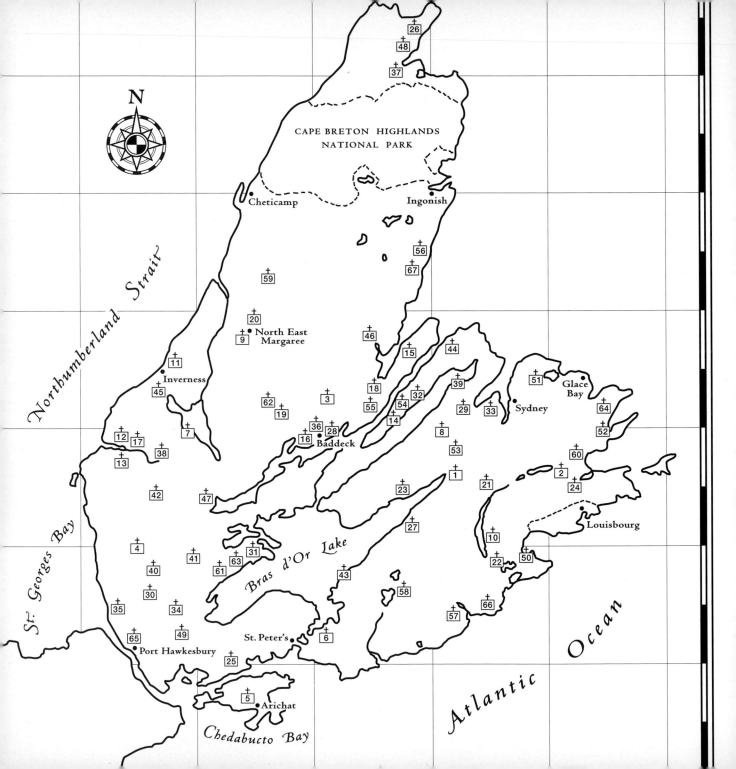

The Wooden Churches of Cape Breton

1. St. Mary's, East Bay
2. Union Presbyterian, Albert Bridge
3. St. Andrew's United, Forks Baddeck
4. St. Margaret's of Scotland, River Denys Mountain
5. L'Assomption, Arichat
6. Immaculate Conception, Barra Head
7. Immaculate Conception, West Lake Ainslie
8. St. Mary's, Frenchvale
9. St. Patrick's, North East Margaree
10. St. Margaret's, Grand Mira
11. St. Margaret's, Broad Cove
12. St. Mary's, Mabou
13. Mabou Pioneer Shrine, Mabou
14. Knox Presbyterian, Ross Ferry
15. St. Mark's Presbyterian, Englishtown
16. Greenwood United, Baddeck
17. Mabou-Hillsborough United, Hillsboro
18. Ephraim Scott Memorial, Glen Haven, South Gut, St. Anns
19. Farquharson Memorial Presbyterian, Middle River
20. Wilson United, Margaree Centre
21. St. Columba Presbyterian, Marion Bridge
22. Zion United, Gabarus West
23. St. Rose of Lima, Northside East Bay
24. St. James Presbyterian, Catalone
25. St. Louis, Louisdale
26. St. Margaret's, St. Margaret Village
27. St. Mary's, Big Pond
28. St. Peter and St. John Anglican, Baddeck
29. St. Columba United, Leitches Creek
30. Princeville United, Princeville
31. Malagawatch United, Malagawatch
32. St. Joachim, South Side Boularderie
33. Incarnation, Edwardsville
34. St. Margaret's, West Bay Road
35. Stella Maris, Creignish
36. St. Michael's, Baddeck
37. First Presbyterian, Cape North
38. St. John the Baptist, Brook Village
39. St. Joseph's, Little Bras d'Or
40. St. Mary's and All Angels, Glendale
41. St. Dionysius, River Denys Station
42. St. Joseph's, Glencoe Mills
43. Sacred Heart, Johnstown
44. St. James Presbyterian, Big Bras d'Or
45. Strathlorne United, Strathlorne
46. St. Andrew's Presbyterian, North River
47. Stewart United, Whycocomagh
48. Aspy Bay United, Aspy Bay
49. Cleveland United, Cleveland
50. Gabarus United, Gabarus
51. St. Joseph's, Lingan
52. Christ Church Anglican, South Head
53. Knox United, Blacketts Lake
54. Drummond Memorial United, Boularderie
55. Glen Haven United, Glen Haven, South Gut, St. Anns
56. Bethel United, Skir Dhu
57. St. Andrew's Presbyterian, Framboise
58. Calvin Presbyterian, Drummondville, Loch Lomond
59. Big Intervale Church, Big Intervale
60. United Baptist, Mira Bay
61. St. Joseph's, Marble Mountain
62. Middle River United, Middle River
63. St. Paul's United, Marble Mountain
64. Port Morien United, Port Morien
65. St. David's United, Port Hastings
66. Fourchu United, Fourchu
67. Calvin United, Birch Plain

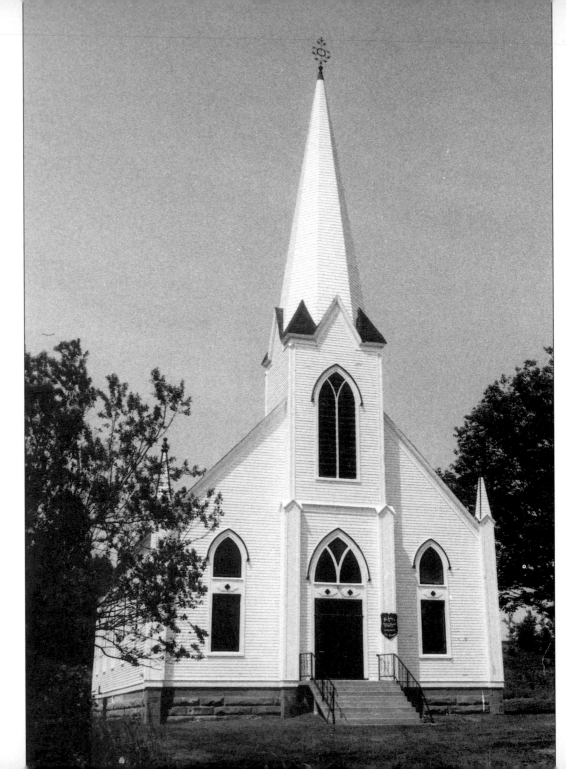

*Strathlorne
United*

THE WOODEN CHURCHES
OF CAPE BRETON

ST. MARY'S
EAST BAY ~ *1841*

ERECTED IN 1841, ST. MARY'S is one of the oldest surviving wooden churches on Cape Breton Island. (L'Assomption at Arichat was completed just four years earlier.) The present church at East Bay and the chapel that preceded it served a small group of settlers who came in the early part of the century from Prince Edward Island.

St. Mary's is a commodious structure, generous in its horizontal dimensions and no less impressive in the vertical, with a steeply pitched roof over an open two-storey interior and an unusually tall square tower and finely tapered octagonal spire.

The tower is imposing and emphasized by the fact that it carries the entire decorative treatment of the front facade (there are no flanking doors or windows). Such was not always the case, however. Beneath the modern aluminum siding are hidden painted wooden quoins at the corners of the church walls and of the tower. The central doorway is architecturally defined, with a pedimented gable enclosing a glazed transom rendered in a Moorish-revival manner. A Gothic window above the doorway is horizontally aligned with the second-floor side windows. A wheel motif at the top front and sides of the tower appears to serve as a stand-in for the more conventional painted clock-face. A particularly pleasing feature is the arrangement of eight ventilator arcades at the base of the spire, each with round-arch moulding and a keystone.

One of the most intriguing aspects of St. Mary's, East Bay, is the fact that the windows represent an inventory of architectural styles. The windows in the lower row are generally of the round-headed type, while those in the upper row are neo-Gothic in design. All have finely built up moulded surrounds, each with a keystone at the centre of the round or pointed arch. The last window on each of the lower rows, that is,

the two windows that are set into the sides of the sanctuary, are of Palladian design; each window is comprised of a round-arched centre section flanked by two rectangular sections. This window type is of much earlier design inspiration, popularized in England by Inigo Jones (the "English Palladio"), and occasionally found elsewhere in Nova Scotia, notably in the design of St. Paul's in Halifax, built in 1756. Most distinctive of all, however, is the placement of an inverted heart in the glazing of the Gothic upper windows, a folk-art variation in a structure of rather formal aspirations.

The interior of St. Mary's retains much of its neoclassical character, with a pedimented gable and flanking columns used to frame the sanctuary. The long U-shaped gallery extends unusually far forward in the church, set on Moorish-style arcades similar to those found at St. Rose of Lima. This style was probably imitated when St. Rose of Lima was established as a missionary congregation of St. Mary's.

UNION PRESBYTERIAN
ALBERT BRIDGE ~ *1857*

ONE OF THE MOST PLEASING of Cape Breton wooden churches, Union Presbyterian is picturesquely situated on a point jutting into the beautiful Mira River. The church can be seen from many hilly approaches, but is most striking when viewed from across the river, a perspective that is especially satisfying in the morning, when the church is mirrored in the water below.

Union Presbyterian was built in 1857, but retains interior features of a much earlier date. It is the only surviving Cape Breton wooden church with its original box pews intact. A horseshoe mezzanine on squared columns creates the impression of a three-bayed nave, leading toward the central focus, a fine panelled pulpit reached by flanking stairways. Suspended above is a rather grand sounding board, richly embellished with elaborate mouldings and dentils.

Unlike those Georgian prototypes from which it clearly derives inspiration, Union Presbyterian reflects the nineteenth-century predilection for the Gothic, here most conspicuously manifested in the pointed-arch windows flanking the Georgian neoclassical sanctuary.

The exterior is no less impressive. The square tower with intermediate lantern and octagonal spire is strongly in the Wren-Gibbs tradition, and the returned eaves suggest a Greek-revival influence. All of this earlier Georgian restfulness is, of course, modified by the upward thrust of the tall Gothic pointed-arch windows that pierce all four walls of the structure.

The faux-painted clock-pieces on the tower, a reminder of the special quality of spiritual time, have their counterparts elsewhere on the Island, notably at Malagawatch United, Malagawatch; St. John the Baptist Church, River Bourgeois; and St. Margaret of Scotland Church, Broad Cove.

ST. ANDREW'S UNITED
FORKS BADDECK ~ 1865

ONE OF FEW NEOCLASSICAL CHURCHES in Cape Breton (others include churches at Malagawatch and Princeville), St. Andrew's United is nearly hidden from public view, and can be reached only by taking a comparatively remote side road northwest out of Baddeck.

Looking back to Greek rather than Gothic ideals, the design of St. Andrew's is essentially that of a pedimented temple. The triangular cape of the traditional temple is only faintly hinted at in the nineteenth-century tendency to substitute short, returned eaves for the continuous line that would otherwise complete the base of the triangle. This simplification was necessitated in both church and domestic architecture because the pediment no longer served as a setting for sculpture, but was rather the functioning upper storey, frequently fitted with windows or louvred openings.

The Protestant simplicity of the interior decor is offset by tall double windows (ten-over-six glazing) that provide generous natural light and a view of nature's own grandeur beyond the walls of this humble meeting place.

ST. MARGARET'S OF SCOTLAND
RIVER DENYS MOUNTAIN ~ *1841*

THE STYLE OF THIS CHURCH is somewhat difficult to define, especially since the building has in fact undergone alterations over the years. It has been suggested that the present church is an enlargement of a tiny original building that was expanded in the 1870s by pulling the ends apart and inserting a new middle section. The idea of building a new middle after the ends have already been joined is certainly unusal.

The church is named for the patron saint of the homeland of much of Cape Breton's population. St. Margaret of Scotland (1045–93) was probably born in Hungary and was brought at age twelve to the court of King Edward the Confessor in England. She was forced to flee to Scotland after the Battle of Hastings in 1066 and was granted refuge at the court of King Malcolm III of Scotland. In 1070 she married Malcolm, and soon proved to be an inspired reformer of both church and state. Her kindness and generosity were renowned, particularly among the poor, whom she held in special regard. She is reported to have adopted nine orphan girls, whom she waited upon with her own hands. She was named patron saint of Scotland in 1673. Four churches on Cape Breton Island, located at Grand Mira, River Denys Mountain, Broad Cove and St. Margaret Village, are named for Margaret. Her feast day is November 16.

The facade of the church is dominated by a central tower, upon which is placed a makeshift eight-sided belfry and ogee-curved roof, probably of later construction. The original double-door entrance at the front is still in use, as is a newer single door on the side of the tower.

A distinctive feature of St. Margaret's of Scotland Church is the placement of three large and unusual windows on each side. The windows are of the round-headed type. Unlike most windows of this style, in which the rounded arch is made in some way integral to the rest of the window or at least to its upper section, here the windows are divided into three stacked sections. The two lower sections are divided because they create a sash-type window, allowing the bottom section to be raised. However, the round-arch section is also separate, breaking the normal integration with the whole.

Even more unusual, however, is the architectural framing of these windows. Rather than using a rounded-arch hood-moulding, which would echo the curvature of the window itself, the round arch here is framed instead within a triangular pediment, creating a strange juxtaposition of the linear and curvilinear.

The interior walls are of simple plank construction, painted blue, with white ceiling colour. A gallery with tongue-and-groove panelling wraps around two sides and the back. The Gothic-style wooden altar has been brought in recent years from St. Mary's and All Angels Church at Glendale, since the decision to modernize the interior of the latter.

This shingled structure is one of the remotest of all Cape Breton churches, situated deep in a forest clearing at the top of River Denys Mountain and reached by a rugged road that could test many a pilgrim's sincerity. The story is told that the site of St. Margaret's was revealed to an unknown woman in a dream. For some time, the church marked a crossroads and the location of a small community.

L'ASSOMPTION

ARICHAT ~ *1837*

IN CONTRAST TO THE MANY GOTHIC-STYLE churches throughout Cape Breton Island, L'Assomption is conceived along Renaissance lines. Even so, its details incorporate elements of both the Gothic and the Romanesque.

This is one of few two-towered wooden churches in Cape Breton. (The others are St. Joseph's at Little Bras d'Or and Stella Maris at Inverness, which may itself be modelled upon L'Assomption.) Here the two towers flank a rounded, deeply inset doorway. Buttresses on the tower corners extend nearly to the top of the first storey. In each tower is a four-level arrangement of doorway, window, window, and louvred opening. The tower doors, like the central entry, are deep-set, with round-headed transoms and applied mouldings. The window immediately above the doorway is a wheel window completely encased in a flat moulding, to which is added a rounded hood-moulding over the top half of the window. Cut into the second storey is a round-head Romanesque form, with central vertical mullion and crossbars. In the upper storey there is a

louvred opening, with a round-headed arch and applied hood-moulding like that on the windows. A keystone motif occupies the centre of the round-arch enclosures on each door and window. The towers are topped by canopied domes, similar to that at St. Joseph's in nearby Petit-de-Grat (which succeeds L'Assomption by seventy-five years and is undoubtedly influenced by its design).

The front has an imposing appearance and expresses Renaissance conception in its architectural detailing. This style uncommon in Cape Breton churches is evident here in the shallow portico enclosing a central doorway and round window. A peaked arch, really an allusion to a triangular pediment, rests upon two-storey fluted classical pilasters. The pilasters rise from simple block bases to built-up capitals, ornamented with heavy moulding and brackets, all contributing to the impression of the facade of a Greek temple.

The Renaissance facade, with its Romanesque overtones (round-headed windows and umbrella domes on the towers), gives way on the sides to a more familiar Cape Breton Gothic style. Here, the surface is dominated by a row of five Gothic pointed windows, as well as the presence of particularly elaborate windows in the sacristy addition. The Gothic appearance of the sides is further amplified by simple, flat buttressing in the spaces separating the windows.

Like its neighbour, St. John's Anglican, the Church of L'Assomption faces east, parallel to the coastal road through Arichat.

IMMACULATE CONCEPTION
BARRA HEAD ~ 1865

THE TWO-STOREY HEIGHT and rectangular plan of Immaculate Conception is reminiscent of the proportions of the New England meeting house and links this structure with St. Mary's at East Bay. In New England this form gave way to the church with square tower and spire above, but in Cape Breton a further development was the preference for Gothic rather than squared windows.

However, the placement of a shortened lantern and cupola on the tower, instead of the characteristic round or octagonal spire, is unusal in Cape Breton churches. The reversing ogee-curve of the cupola is similar to that on Stewart United Church at Whycocomagh.

The real charm of Immaculate Conception is found in the interior, greeting the visitor immediately upon entering. The light is especially beautiful here: large, wide Gothic windows along the east and west walls provide a continuous stream of light, both morning and evening, illuminating the softly stencilled walls and galleries and the grain-painted panelled doors that flank the altar. The stations of the cross are set in handmade scrolled frames, with inscriptions painted in the Mi'kmaq language. Ornamental details are many, including plaster sunflowers on the mouldings where they are joined at the top of the Gothic window arches. On the double stairway leading up to the choir loft and upper gallery is one of the most extraordinary local folk-art expressions—beautifully carved human hands at the lower ends of the handrails.

Especially attractive about Immaculate Conception Church is its unspoiled condition (apart from a new enclosure over the front doors). It is most unusual to find an interior that still has its original altar, window glazing, decorative painting, stencilled designs (some restored or renewed) and other details.

Immaculate Conception
West Lake Ainslie ~ *circa 1872*

ONE OF THE LOVELIEST of all wooden structures in Cape Breton is this light Gothic church built around 1872 alongside the largest freshwater lake on the Island. The style of Immaculate Conception is beautifully Gothic, with occasional neoclassical details, notably in the returned eaves of the roof.

The tower is one of the prettiest in Nova Scotia, although marred by the unsympathetic insertion of modern doors and a crude canopy. Like other churches, the tower here is divided into three storeys, but generous expanses separate each level. The crowded placement of windows—a modest problem at St. Francis de Sales Church in River Inhabitants and a severe one at Princeville United—is thus avoided here.

Above the entry stands a Gothic tower window that is among Cape Breton's most attractive (along with ones at St. Margaret's, Broad Cove; St. Joseph's, Glencoe Mills; and Farquharson Memorial Presbyterian in Middle River). Windows at West Lake Ainslie are divided into three internal lancets, the centre one shortened to accommodate a quatrefoil frame between it and the point of the arch. Thin vertical mullions within each lancet contribute to the delicacy of the entire structure. At the third storey is a shorter Gothic window with a flattened arch, itself divided into two internal lancets between whose points is placed a small quatrefoil frame. Atop this already tall tower is a splendid octagonal spire with a finely tapered pinnacle. It rests on an eight-sided base with gabled louvred openings. The tower is flanked by two large, tall Gothic windows, each similarly divided into two internal lancets enclosing a quatrefoil device.

The side windows are ingenuously constructed. While giving the appearance of two-storey Gothic windows, each is in fact divided into a lower and an upper window, placed below and above the balcony running the full length of the interior wall. The upper section is a Gothic arch enclosing two lancets with a quatrefoil beneath the arch; the lower section is rectangular and also encloses two Gothic lancets. So slender is the horizontal division between the window sections that it is difficult to see them as anything other than continuous tall enclosures. Hence, the soaring verticality of this fine

church is sustained, even when complicated by the necessities of the interior structure.

The interior of Immaculate Conception is in every way as successful as the exterior. It is divided by two rows of cluster-columned piers in a three-part floor plan with nave and flanking aisles, above which runs a balcony along the sides and back. The placement of balcony, arcading, and the upper sections of the windows in the side walls creates a nineteenth-century equivalent to the triforium level of the medieval Gothic cathedral, similar to that at Union Presbyterian Church in Albert Bridge, but much taller and loftier in effect.

The ceiling is vaulted—not steeply as at Glendale, but rather in the manner of a flattened Tudor Gothic arch, without ribbing. The piers are a full two storeys in height, supporting a horizontal beam upon which rests the roof. These piers consist of a central shaft, enclosed within four half-round columns, creating a cluster-column effect.

One of the delights of this fine church is the well-preserved interior. The pine altar, a solid expression of Carpenter Gothic work, is interesting in the way it continues the quatrefoil theme of the windows. The lower part of the altar consists of four framed panels—an arrangement of circles within squares, and within each circle a quatrefoil design. An unusual feature is a small wheel window, high above the altar and rather insignificant in its diminished size, but unfortunately the window has been covered over from the exterior by modern siding. The pews are also of Gothic design, and those in the balconies retain their original grain-painted finish, although the ones on the main level have been painted over.

Immaculate Conception Church is one of the jewels of Cape Breton architecture —a marvellous sight to come upon while driving through the West Lake Ainslie countryside, and nearly as perfect as it was at the time of construction more than a century ago.

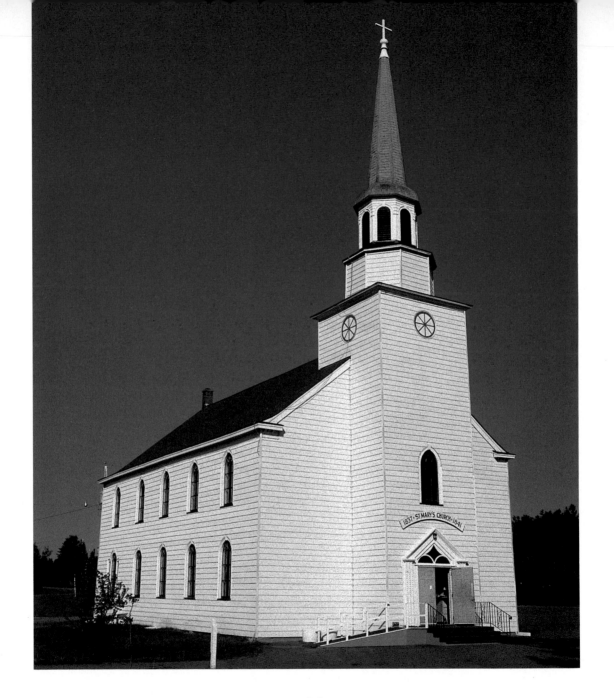

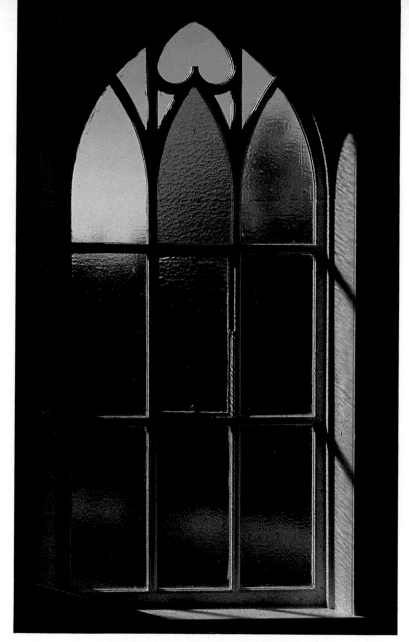

Left: St. Mary's, East Bay
Above: St. Mary's, East Bay, window with heart

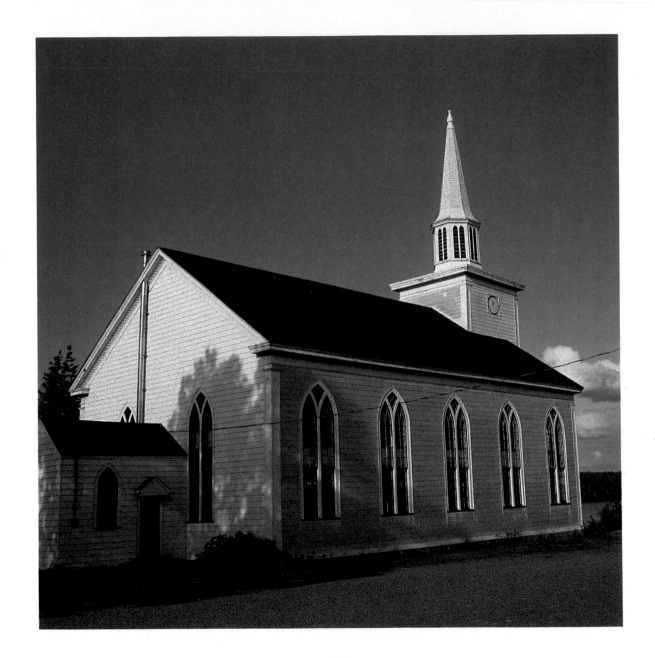

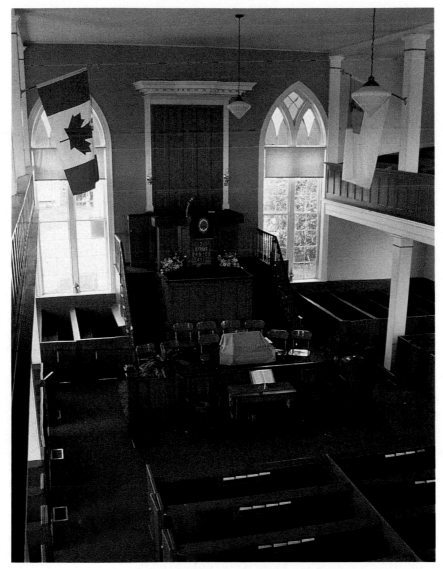

Left: Union Presbyterian, Albert Bridge
Above: Union Presbyterian, Albert Bridge, nave, box pews and pulpit

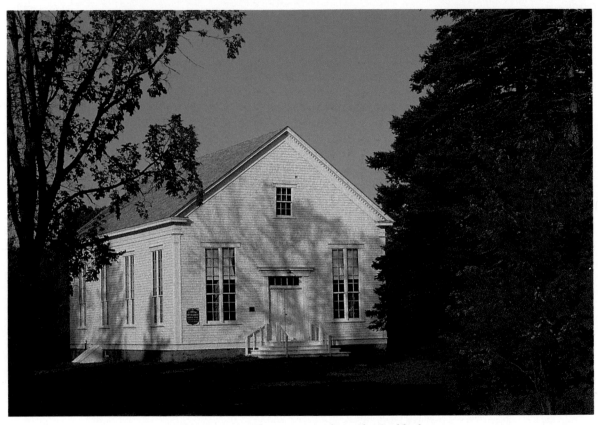

Above: St. Andrew's United, Forks Baddeck
Right: St. Margaret's of Scotland,
River Denys Mountain

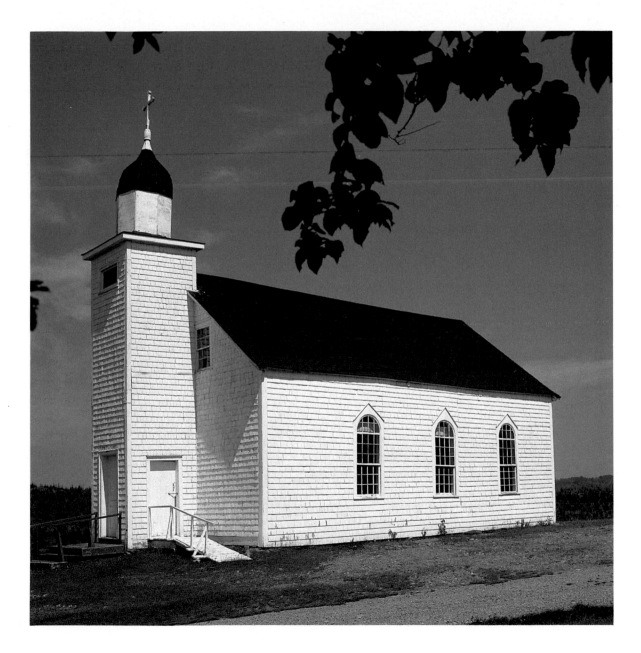

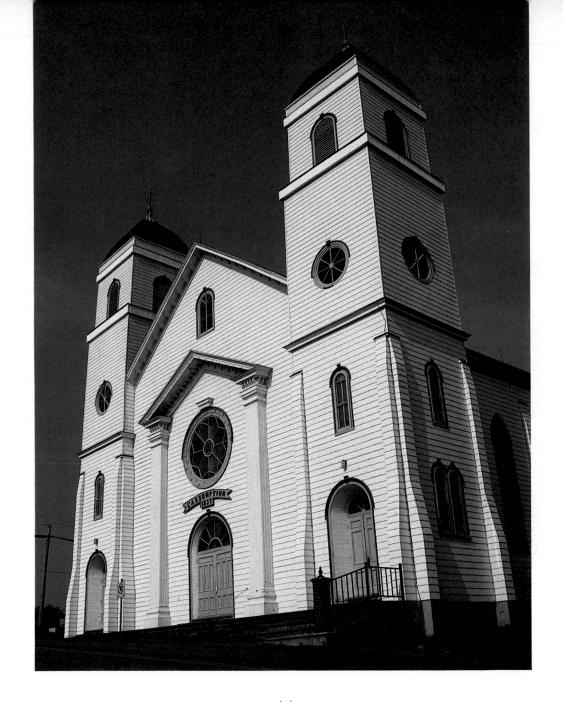

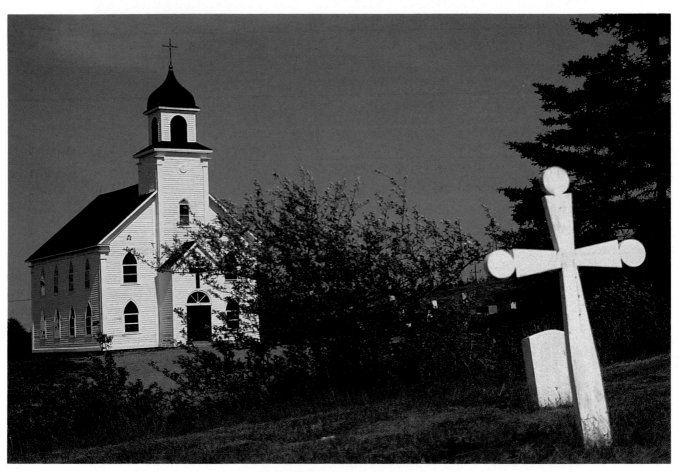

Left: L'Assomption, Arichat
Above: Immaculate Conception, Barra Head

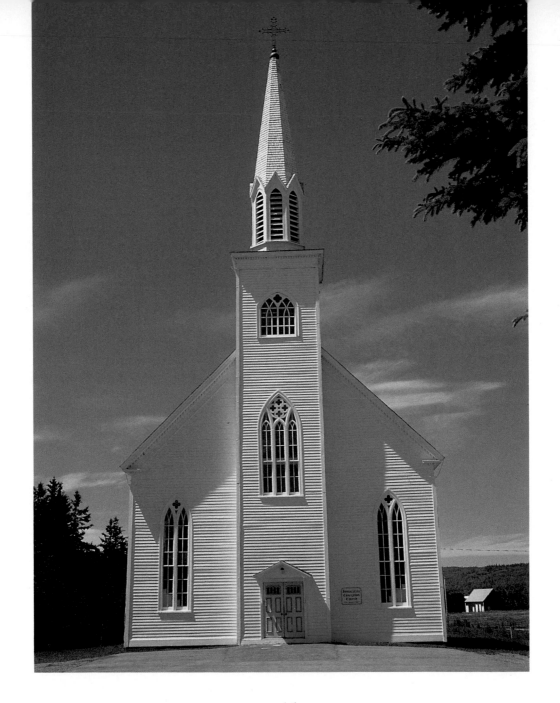

46

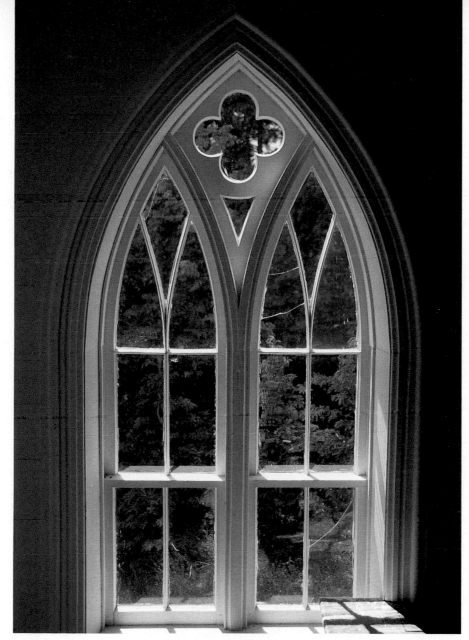

Left: Immaculate Conception, West Lake Ainslie
Above: Immaculate Conception, West Lake Ainslie, Gothic window

48

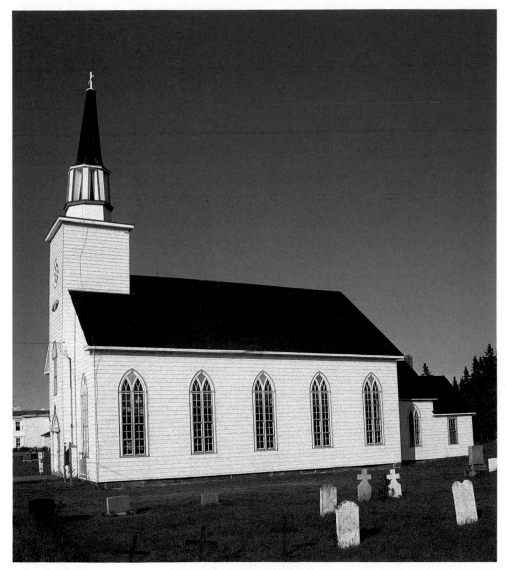

Left: St. Mary's, Frenchvale
Above: St. Patrick's, North East Margaree

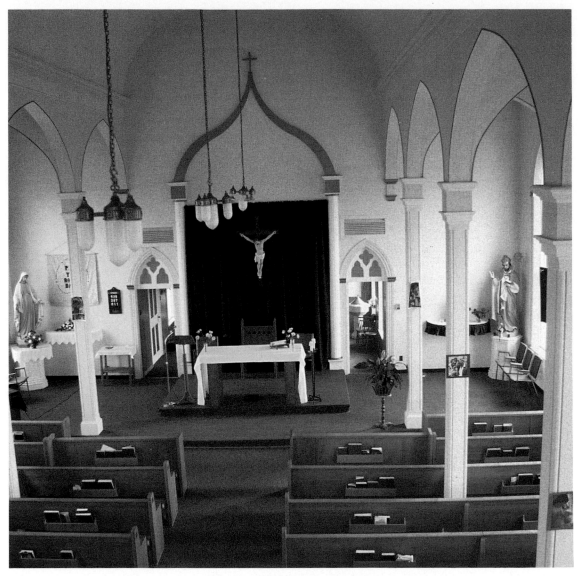

Above: St. Patrick's, North East Margaree, nave and sanctuary
Right: St. Margaret's, Grand Mira

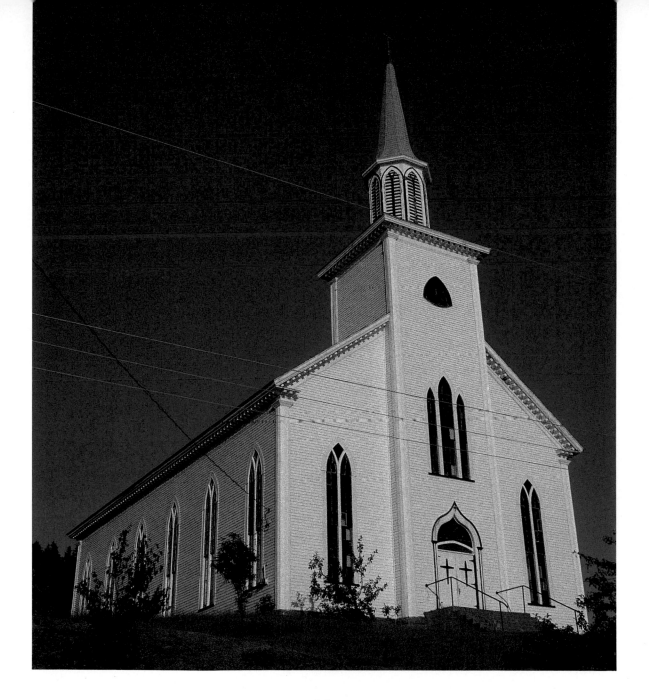

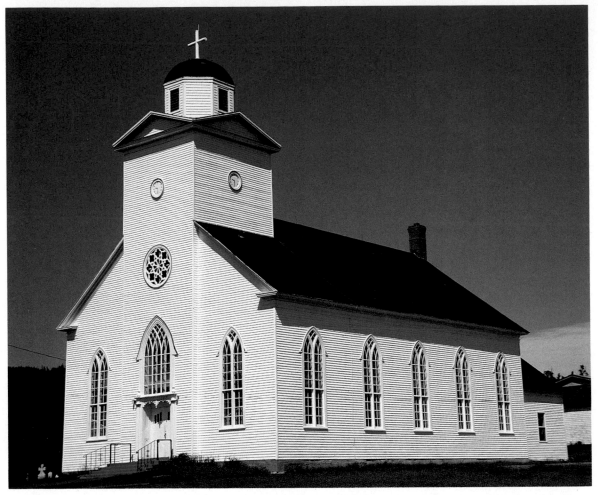

Above: St. Margaret's, Broad Cove
Right: St. Mary's, Mabou

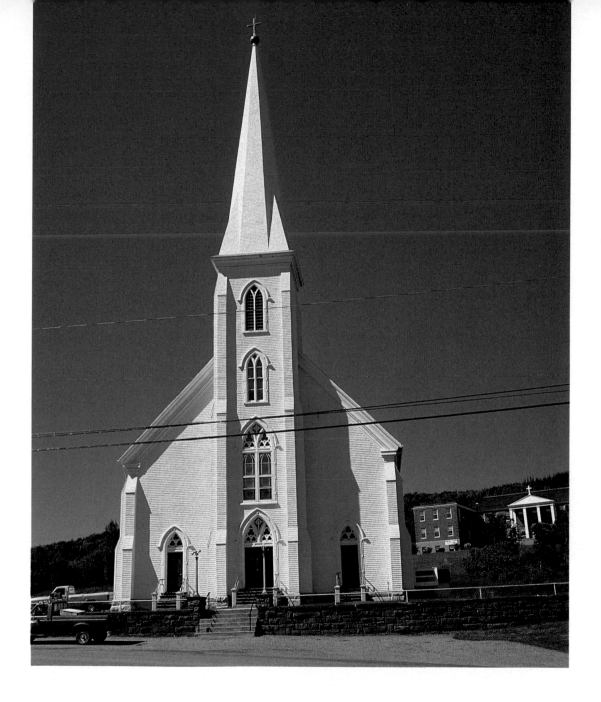

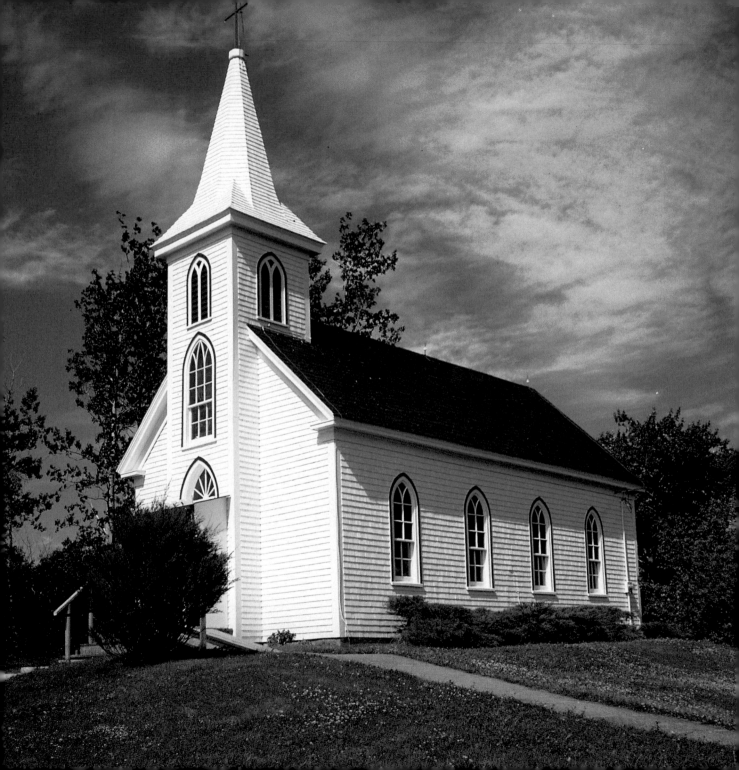

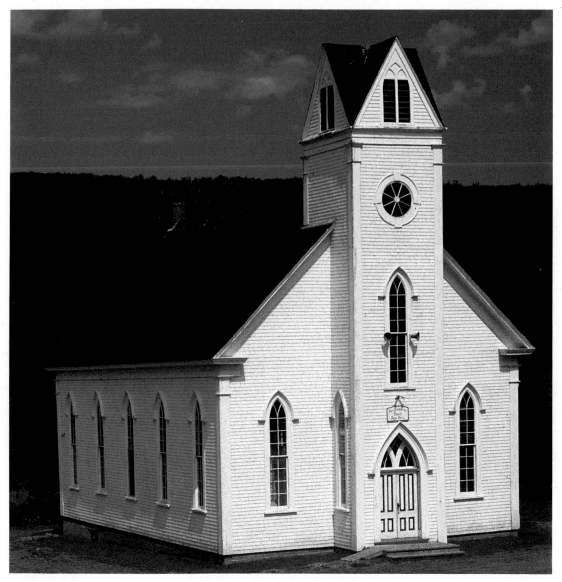

Left: Mabou Pioneer Shrine, Mabou
Above: Knox Presbyterian, Ross Ferry

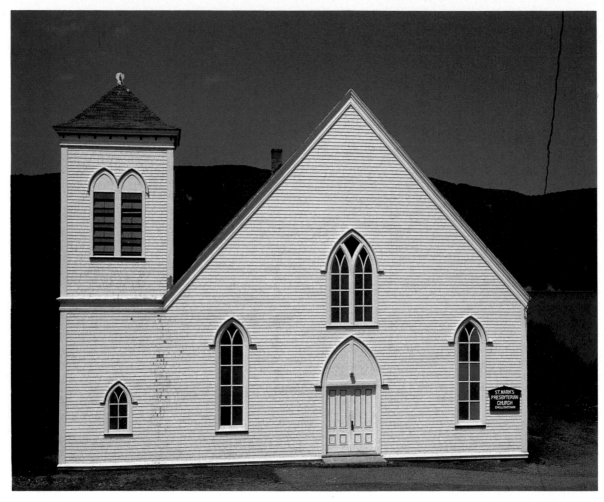

Above: St. Mark's Presbyterian, Englishtown
Right: Greenwood United, Baddeck

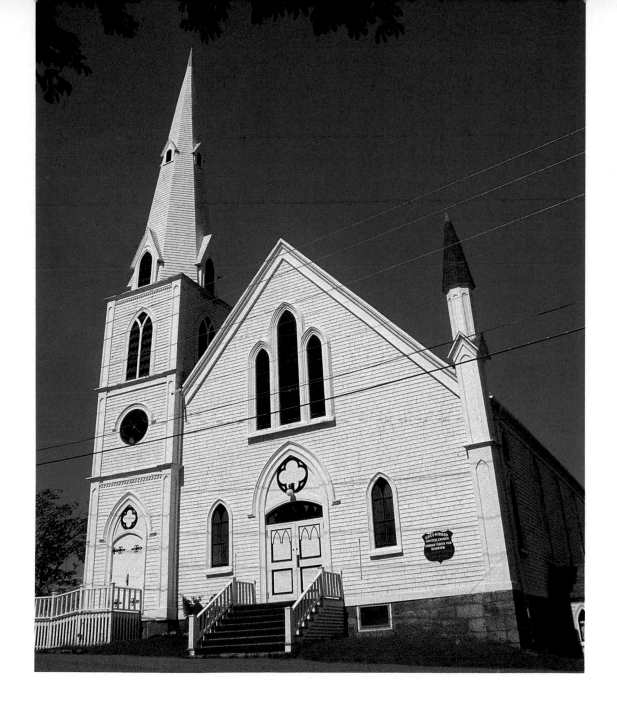

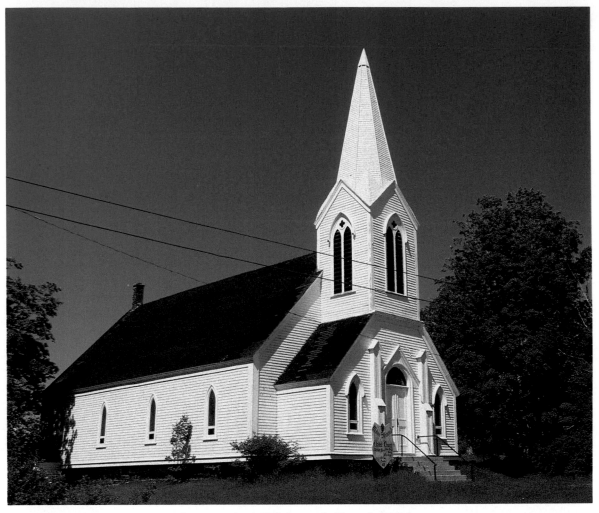

Above: Mabou-Hillsborough United, Hillsboro
Right: Ephraim Scott Memorial, Glen Haven, South Gut, St. Anns

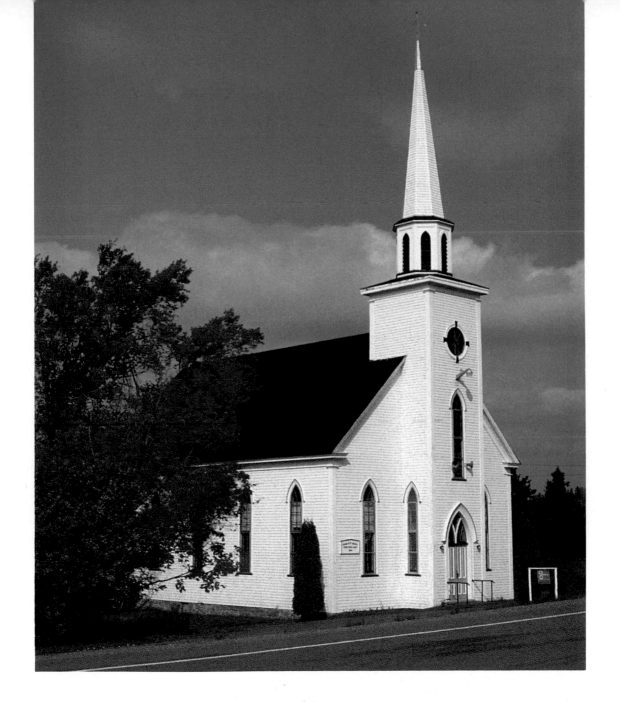

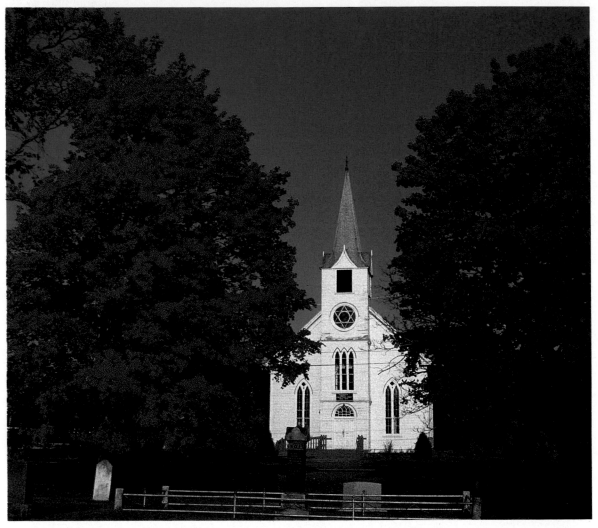

Above: Farquharson Memorial Presbyterian, Middle River
Right: Wilson United, Margaree Centre

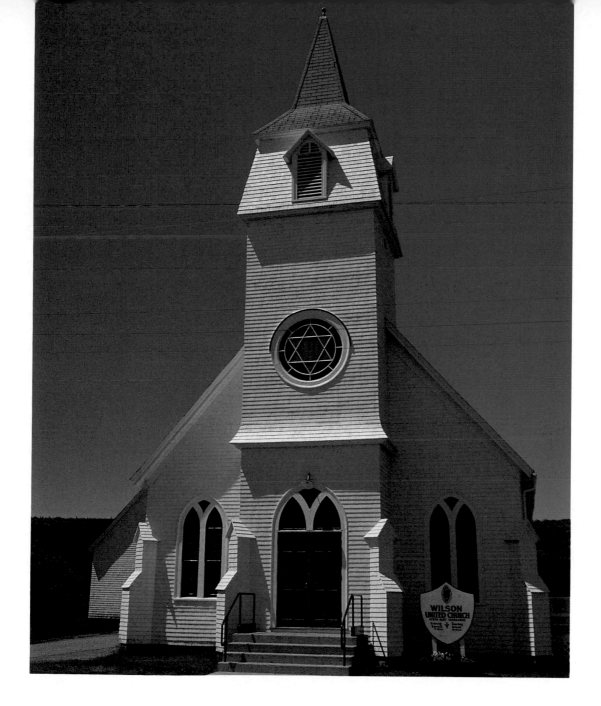

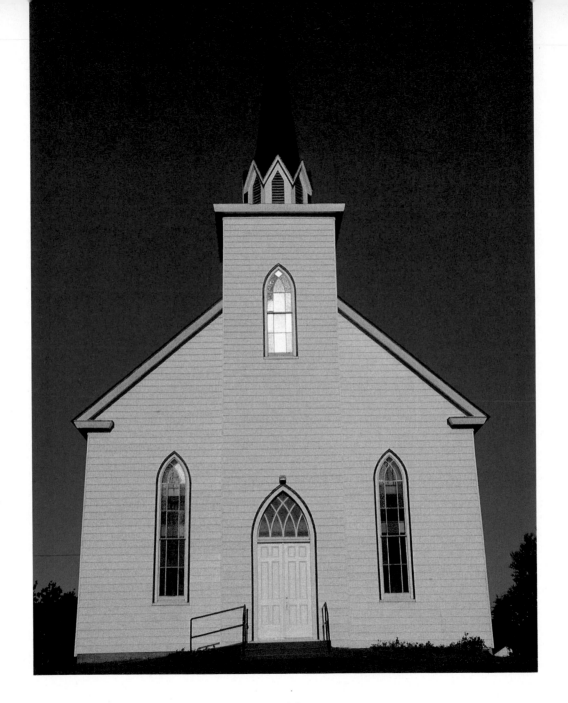

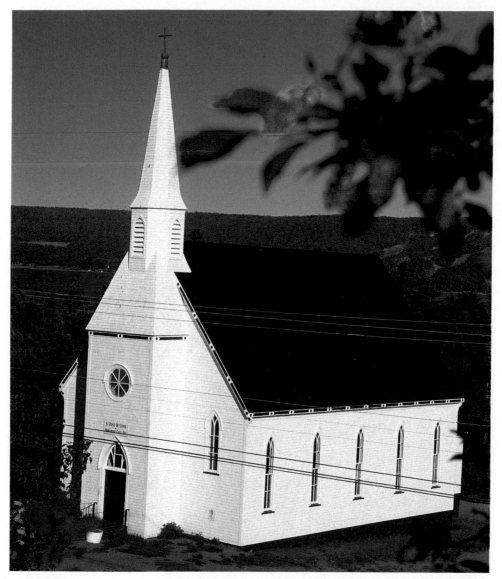

Left: St. Columba Presbyterian, Marion Bridge
Above: St. Rose of Lima, Northside East Bay

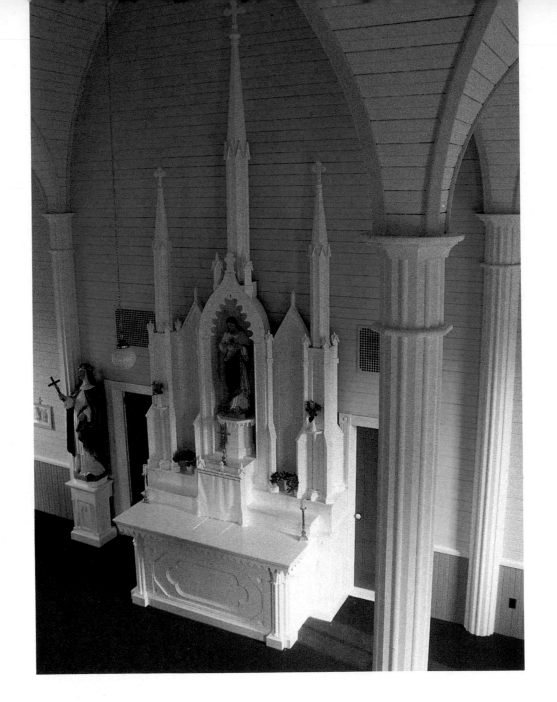

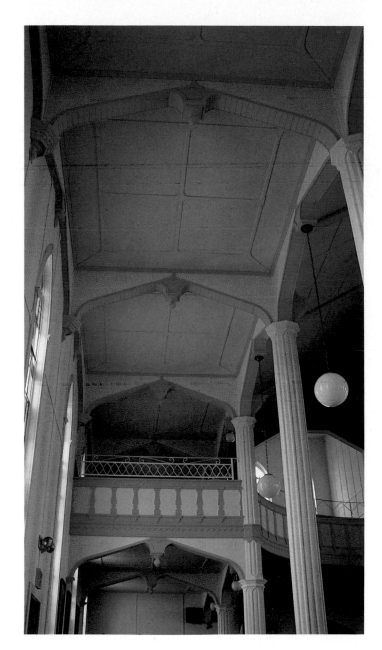

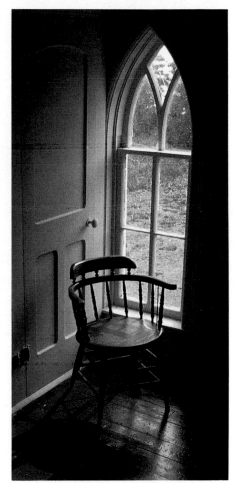

Far left: St. Rose of Lima,
Northside East Bay, sanctuary
Left: St. Louis, Louisdale, aisle
Above: St. Rose of Lima,
Northside East Bay, vestry

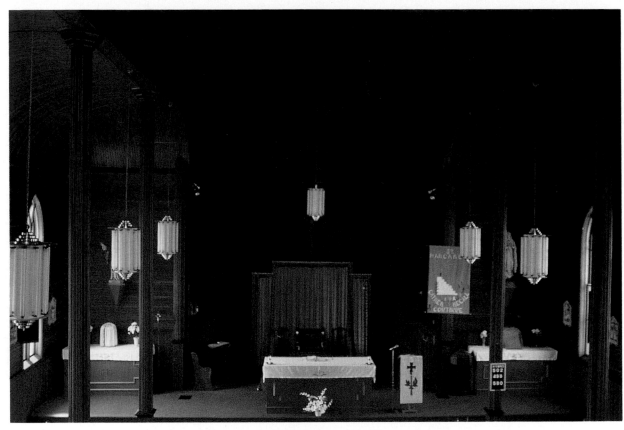

Above: St. Margaret's, St. Margaret Village, vaulting
Right: St. Mary's, Big Pond

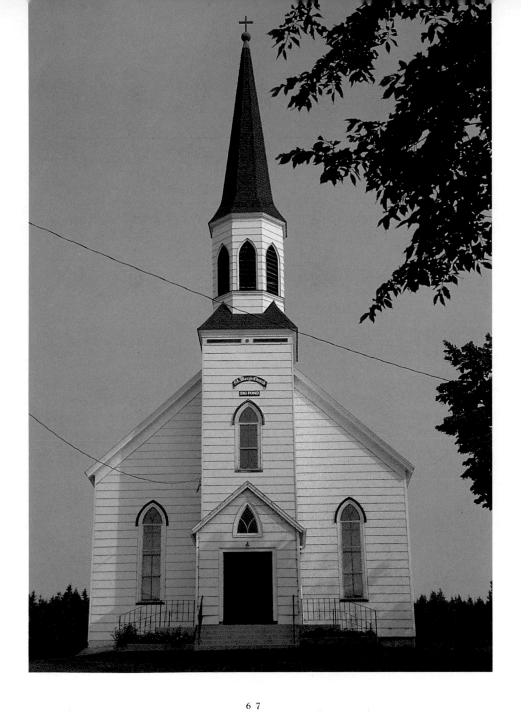

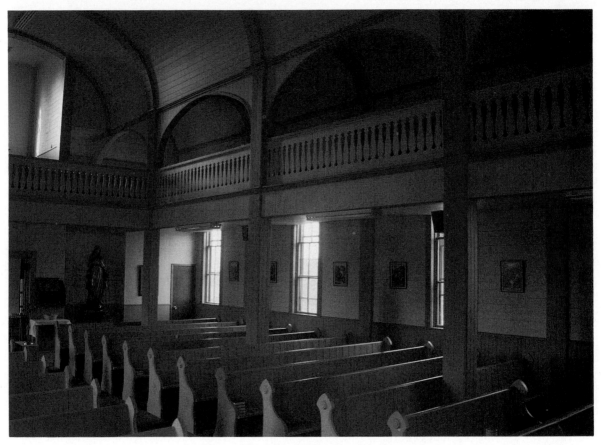

Above: St. Mary's, Big Pond, nave
Right: St. Peter and St. John Anglican, Baddeck

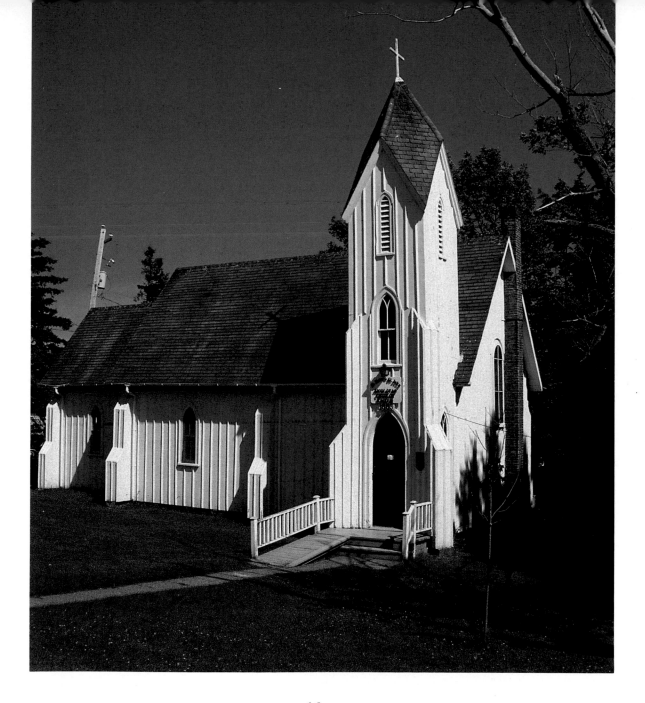

ST. MARY'S
FRENCHVALE ~ *1858*

THIS EXTREMELY PRETTY CHURCH is of comparatively early date and has undergone relatively few changes in its exterior construction, a modest exception being a small stone porch added to the front, enclosing the original doorway. Unfortunate interior alterations include the installation of modern pews and the unsympathetic covering of the walls with common sheet panelling.

The square tower is almost flush with the facade. While the sides and back of the tower have square openings fitted with modern, metal louvred inserts, the front is distinguished by a particularly attractive full-length Gothic sash window situated in the landing and second storey above the entry. This window has finely articulated tracery in the uppermost section, below which are two sections with an arrangement of twenty-over-sixteen panes.

The tower is flanked by two large Gothic windows identical to the one in the tower. Returned eaves and a simple bargeboard complete the facade and roofline.

The strikingly tall Gothic windows along the sides—three on the north and south sides respectively, as well as an additional window on each of two angled walls in the apse—give this small church one of the airiest interiors on the Island. The interior retains its original balustraded balcony, which runs along the side walls and over the entrance. The apse is itself an unusual feature on Cape Breton wooden churches, with few known counterparts (one modest example being the apse at Cape North United Church). Its three-sided construction makes it reminiscent of French medieval prototypes, in contrast to the more characteristic square apse of English country churches.

St. Mary's at Frenchvale, one of the Island's most charming churches, is set near the top of the hill, looking southwest over a beautiful wooded valley. The grounds are handsomely landscaped, and the abundance of flowering trees and shrubs assure that when all is in bloom in late spring this splendid little place of worship is most picturesque.

ST. PATRICK'S

NORTH EAST MARGAREE ~ 1871

SITUATED IN THE EXTRAORDINARILY SCENIC valley of the Margaree, St. Patrick's of North East Margaree is attractive by virtue of its design and its setting. The unsually light interior of St. Patrick's is the result of large, floor-to-ceiling double-lancet windows at the front and sides. The placement of five sets of windows along the sides of a medium-length structure imparts an extraordinary sense of spaciousness.

As with many Cape Breton churches, much of the decorative treatment of the exterior facade is concentrated in the tower. Here, the square tower is punctuated by a doorway, a double Gothic lancet and a circular window, in order from bottom to top. The circular window is actually a composition of eight quatrefoils and a central rosette cut from a wooden plate. The transom is, in similar fashion, a pattern of motifs cut from a plate—in this case, a grouping of trefoils. The arch over the door and transom is Moorish in character, being defined by a reversing ogee-curve. The design of this arch is similar to that of the ogee arch found over the doorway of St. Margaret's at Grand Mira. At St. Patrick's, the meeting of the ogee elements culminates in a decorative fleur-de-lis motif, and the shape of the arch has its interior counterpart in the design of the arch over the sanctuary.

An unattractive debasement of the good lines of St. Patrick's Church is the crude replacement for the original spire that was lost some years ago.

ST. MARGARET'S
GRAND MIRA

HIGH ON THE BLUFF overlooking the valley below, St. Margaret's Church takes a commanding place in the hilly landscape along the Mira River. This commodious place of worship is of monumental proportions and was intended to serve as a highly visible spiritual reference point for the surrounding countryside.

The eclectic nature of Cape Breton churches is as apparent at St. Margaret's as anywhere on the Island. The returned eaves, flat pilasters, and capitals at corners of the facade and tower convey a strong neoclassicial seriousness, given unusual reinforcement here by closely spaced roof brackets, which appear from the distance as enormous dentils. Yet, as with the overwhelming majority of churches in the region, it is the Gothic revival that predominates. Pointed arches define double-lancet windows on the sides and west facade, louvres in the lantern, and the triple lancets in the tower. The profile of the arch over the doorway is of special interest here, in that it uses the principle of reversing ogee curves, defining what is commonly called a Tudor, or Moorish, arch. A similar treatment can be seen in the doorway and over the sanctuary of St. Patrick's Church in North East Margaree.

ST. MARGARET'S
BROAD COVE ~ 1853

ONE OF THE TRULY SPLENDID wooden churches on the Island, St. Margaret's at Broad Cove is situated on a small rise, behind which are majestic hills and, to the west, vistas of the Northumberland Strait. This fine place of worship is one of four churches on Cape Breton Island named for St. Margaret of Scotland, and a large painting of the saint is given prominence in the sanctuary.

The three great windows in the west facade call to mind the medieval Trinitarian symbolism. The doorway and tripartite pointed-arch window above merge into one soaring entryway. Above, in the upper storeys of the tower, are set a complex rose-window and paint-simulated clock.

St. Margaret's abounds in ornamental detail. Running over the doorway is an entablature with cutout and Gothic drip-finial decoration, creating an impression of stalactites. The bottom ends of the hood mouldings here and on the side windows are flared outward, and the Gothic bar-tracery is unusually fine. An interesting feature of the tracery is the manner in which it continues through the heavier frames of the window sections, unifying the various parallel components into one beautifully pointed whole.

The interior is as impressive as the exterior. A wide nave is flanked by two aisles, divided from the centre by rows of columns and a gallery with arcading rendered in the form of flattened, or Tudor, arches. The altar, built in the period 1896–1904, is of refined workmanship. Its columns and arcading, enriched by a wealth of carved detail, notably a symbolic sunburst, triangle and depiction of the Paschal Lamb, give it the appearance of a baldacchino. Over the altar table is draped the Cape Breton tartan.

ST. MARY'S

MABOU ~ 1897

THE GRAND CHURCH OF ST. MARY'S is visible from many directions as one approaches this charming village situated in the great hills of western Cape Breton. It possesses the finest spire on the Island, soaring 150 feet (46 m) into the air (at that, shortened by some 20 feet (6 m) from its original height). The enormous tower is made all the more spectacular by the most unusual provision of openings on four levels, each capped with a pointed Gothic arch, accentuating the already strongly vertical character of this imposing edifice.

Besides the illusion of three portals created by facades with central door and flanking windows, St. Mary's has three actual doors, leading directly into its large nave and side aisles. An unusual degree of attention has been given to complexity of details, expressed here in the unique use of flat framing members to enclose doors and windows and in keystone-like motifs set at regular intervals along the surrounds. Further detail is seen in the highly sculptural hood mouldings and in elaborate clusters of quatrefoils in transoms.

The town of Mabou is steeped in musical tradition, most recently borne out by the enormous popularity of the Rankin Family singers, known internationally through their performances and recordings. Music has had a central, if controversial, place in the life of the congregation of St. Mary's and is the subject of an oft-told anecdote, according to which, in the 1870s, Father Kenneth H. MacDonald "had the habit of confiscating all the fiddles upon which he could lay his hands." It is reported that at one point there had grown such a collection of forbidden instruments in the glebe house that a local doctor argued with Father MacDonald the point of whether it was proper in the eyes of the Lord to have in his possession things which belonged to others. Father MacDonald was inspired to return the instruments to their owners, "but in only a matter of short time fell back into his constabular ways." It is interesting today that a prominent granite tombstone in the cemetery at St. Mary's commemorates Donald Joseph ("Dan J.") Campbell as a notable fiddler and as composer of "Mist over Cape Mabou." In addition, the sign at the entrance to Mabou takes the form of a painted depiction of the St. Mary's spire and a fiddle, shown side-by-side. What was once condemned in word was later praised in wood and stone.

MABOU PIONEER SHRINE
MABOU ~ 1929

POSSIBLY THE TINIEST CHURCH IN CAPE BRETON, the Mabou Pioneer Shrine is a popular place to visit on a beautifully landscaped knoll across the river to the south of the town of Mabou. This diminutive structure is a splendid statement in miniature Gothic, clad in shingles and painted white with cheerful red mouldings around windows and louvred openings.

The original church, built in 1929, was located 3 miles (almost 5 km) away, at Indian Point, and the pioneer cemetery for the congregation has been recently restored, with damaged stones repaired and overgrowth cleared to provide access for visitors.

KNOX PRESBYTERIAN
ROSS FERRY ~ *1887*

FEW CHURCHES have as pleasing an approach as does Knox Presbyterian at Ross Ferry, located directly across Boularderie Island from tiny St. Joachim Church. The shingle-clad Knox Presbyterian first comes into view from above, rather than from below, as is more customary. Looking down on Knox Presbyterian from the paved road, one is instantly impressed with its harmonious setting—a grassy clearing at the front, surrounded by an immense stand of trees, and beyond, the deep blue waters and the forested far shore of the Bras d'Or Lake.

Apart from a neoclassical suggestion in the returned eaves and defining of the square tower by means of corner pilasters and the four-sided triangular pedimented roof above, this is a finely wrought statement of Gothic revival. Its lancets—three at the front and five on each side—are graceful in their narrowness and great height. The verticality of windows is emphasized by that of the doorway, where the double doors are defined by tall, narrow panels, and the entrance is capped by a pointed arch within which is a three-part Gothic transom. Doors and windows are highlighted by hood mouldings with outwardly flaring stops at the bottom. The circular window is strikingly set off by a continuous flat moulded surround, with moulded edge and keystones at the four cardinal points.

ST. MARK'S PRESBYTERIAN
ENGLISHTOWN ~ *1893*

PRESBYTERIAN MISSIONARY activity in the nineteenth century saw the image of the widely cast net as a pertinent metaphor, and the architecture of St. Mark's nicely echoed that symbol. Even without its corner tower, this church is unusual for the enormous expanse of its facade.

The tower, occurring as a feature of domestic architecture at the middle and in the second half of the century, is almost Italianate in feeling. The tower may have been an afterthought, later constructed at the corner (during a time when churches were introducing corner entrances and towers), perhaps to make up for the failure to pro-

vide the more customary central tower when the church was erected. It is even possible that the entire facade is newer than the original structure, given the fact that, on the side, the spacing between the first and second lancets is narrower than the spacing between the second through the fifth.

The panelling of the double doors is identical to that at Knox Presbyterian, Ross Ferry, but the slightly wider flanking lancets, the double-lancet Gothic window above, and the uncharacteristically wide spacing of openings make the appearance of St. Mark's unique on the Island.

St. Mark's is situated close to the ferry crossing, where St. Anns Bay makes a scenic backdrop.

GREENWOOD UNITED
BADDECK ~ 1893

GREENWOOD UNITED is one of the Presbyterian congregations that joined with other denominations in the merger of 1925.

Although Greenwood United is similar in size to many other wooden churches in Cape Breton, its location on a steeply rising hill and the placement of the unusually large tower on the uppermost corner of the church site create an impression of enormity. Further strength of definition and sculptural depth is given by heavy mouldings on windows and doors, and by the elaboration of panelled pilasters, horizontal mouldings and friezes. The continuous, well-rounded mouldings that enclose the triple Gothic lancets are particularly striking. For sheer verticality, few churches in this area are as impressive. The eye soars upward, an effect compounded by the approach from the steeply ascending roadway, and by the rhythm of pointed-arch doorways and windows, towers, towerlets, gablets and slender spire.

The facade is rich in decorative treatment. Gothic ornamentation takes several forms, in moulded arches applied to the central doors, mimicking the windows and upper doorway sections, as well as in louvred openings in the tower. Another applied device, that of quatrefoil designs in the tympana of the doorways, provides an interesting alternative treatment to the pierced tracery motifs found at St. Joseph's at Glencoe Mills, and St. James at Big Bras d'Or.

MABOU-HILLSBOROUGH UNITED
HILLSBORO

THE PLAQUE indicates the year 1821, marking the establishment of the first congregation on this rugged hillside to the east of Mabou. The church building itself more likely dates from 1888, and possesses notable structural similarities to Strathlorne Presbyterian, a short distance to the north. The original structure was built 2 miles (a little over 3 km) across the river, where a pioneer cemetery still stands.

The special appeal of this church is the dramatic effect its facade, a large square tower flanked by side chambers, the octagonal spire, and the heavily rolled mouldings around doors and simple lancet windows. Further sculptural relief is achieved by the stepped buttresses on each side of the central doorway, aligned to the corners of the tower.

The moulded details of Mabou-Hillsborough United and several other churches (Strathlorne United; Stewart United, Whycocomagh; Middle River United) are unusually pronounced. The mouldings are shaped almost like a ship's keel; the sides follow a convex curvature and their extension into space from the facade is exaggerated. The bottom ends of the hood mouldings culminate in circular bosses, a feature that is found on several other churches in the area.

The sculptural character of the facade is in marked contrast to the simplicity of the windows, which have no bar tracery, and to the severity of the sides, where only three windows punctuate the length of the walls.

EPHRAIM SCOTT MEMORIAL PRESBYTERIAN
GLEN HAVEN, SOUTH GUT, ST. ANNS ~ *1894*

EPHRAIM SCOTT MEMORIAL is another of Cape Breton's churches that beckons to the traveller passing immediately in front of its doors. Erected in 1894, it is situated snug up against the roadside on the route between Baddeck and Kelly's Mountain. This spot at South Gut, St. Anns, has for decades been known as Glen Haven. Much of the beauty of this structure derives from its unaltered character, notably in the retention of its original panelled doors (which in the case of many churches are all too often replaced by unsympathetic modern versions).

The lines of outer structure and inner details are beautifully accentuated here. Flat pilasters serve to outline the rooflines and corners of the church and its tower, while heavily rolled hood-mouldings give sculptural expressiveness to the Gothic arches of door and windows.

FARQUHARSON MEMORIAL PRESBYTERIAN
MIDDLE RIVER ~ *1877*

THIS LARGE PLACE OF WORSHIP is strongly in the Gothic-revival style, but there are other vestigial styles visible here, too. The returned eaves and flat corner pilasters with capitals are of neoclassical inspiration, and the round-arch door transom is faintly Romanesque in feeling, calling to mind the tympanum over the central portal of its distant prototype.

The tower of Farquharson Memorial is very striking, with its unusual height and exceptional wealth of detail. The three-part lancet is related to the one at St. Joseph's Church, Glencoe Mills, while the star tracery in the circular window above has its counterpart at Wilson United in Margaree Centre. The fenestration of front and sides is pleasing, with double Gothic lancets and tiny quatrefoil motifs within the enclosing pointed arch of each pair of lancets.

The grouping of churches and cemetery in this beautiful wilderness alongside the Middle River, approached by the bridge from the southwest, creates one of the most welcoming of sacred places on the Island.

WILSON UNITED

MARGAREE CENTRE

WILSON UNITED is a stalwart place, attractive enough but not given to delicacy of design or proportion. The star motif in the circular window of the tower is akin to that at Farquharson Memorial in Middle River, in both cases comprised of two intersecting triangles, suggestive of the Star of David.

The massive tower, with overhanging upper sections, is a little overpowering for a structure as small as Wilson United. And, as if this were not enough of a statement in solidity, stepped pseudo-buttresses reinforce the sides and corners of this modest structure. The wide double-lancet windows are squat in proportions and barely recognizable as pointed-arch openings.

ST. COLUMBA PRESBYTERIAN

MARION BRIDGE

THE CHURCH IS SMALL but is attractive in its largely unaltered state. Gothic windows flank a similarly styled doorway with a finely traceried transom. The louvred openings in the base of the spire are of Carpenter- Gothic form, following the lines of the gablets on eight sides. The church occupies a pretty setting, lying parallel to the Mira River.

ZION UNITED

GABARUS WEST

ZION UNITED CHURCH at Gabarus West recalls design aspects of Calvin Presbyterian, Drummondville, and St. Andrew's, Framboise. The heavy, square corner towers are here more closely incorporated within the structure of the church itself and are contained within its roofline. The gabled pediment over the shallow porch echoes the fully extended porches at the other two churches. The compression of these neoclassical elements, as well as the more consistent use of pointed-arch windows, gives the Gabarus West church a more Gothic and less eclectic character than its kindred structures in this region of the Island.

ST. ROSE OF LIMA
NORTHSIDE EAST BAY ~ *1891*

ONE OF A PAIR of identical structures (the other is at Lingan), St. Rose of Lima Church occupies an exceptionally beautiful location, on an island where so many churches are found in lovely settings.

This shingle-sided structure is rendered in Gothic-revival style. The tower and spire create an unusual profile due to a sloped transitional zone between lower and upper sections, necessitated by the fact that the tower does not clear the roofline. In contrast to the more conventional way of handling the relationship between a wide tower and narrow spire, through construction of a vertical gradation of diminishing terraces, the approach here is more of a shortcut, inserting a flared intermediate section joining top to bottom.

Against the massive boxlike tower, the Gothic doorway and tiny eight-spoked wheel-window seem a bit understated. Some lightening of the facade is achieved by Gothic louvred openings in the base section of the octagonal, tapering spire, and by stepped hood-mouldings around the Gothic transom and flanking lancet windows. An interesting decorative treatment is the ball-and-dart moulding found along the underside of the roof edges on front and sides alike.

The interior is charmingly neo-Gothic, with pointed arches, fluted columns and unusually high vaulting. The altar is festooned with spires and pinnacles. A gallery for additional seating extends forward and over the entryway to the church.

In recent years a poured cement stoop has been installed at the front entrance. A thoroughly delightful feature is the ornamental ironwork flanking the stoop, embellished by the forms of trumpeting cherubim, cut from sheet steel, who direct visitors across the threshold and into the church.

Few settings are more beautiful than that of St. Rose of Lima. The church, facing northwest, is situated between the road and the shore of East Bay. Viewing the church from the high bluff on the west side of the paved road, one's gaze takes in the great expanse of water, the far slope, and the dramatic appearance of the white steeple reaching upward through the surrounding trees.

St. Louis
Louisdale

THE STYLE OF ST. LOUIS CHURCH is essentially Gothic revival, without the neoclassical details found on many churches of the region.

This is a solid, sturdy place of worship. Note that the tower at Louisdale is square but broached at the top, a device designed to provide continuity between the four-sided structure below and the octagonal section above. Unlike such church structures as St. Mary's in Mabou, St. Louis terminates abruptly, with a squat octagonal lantern and roof resting on the square tower. There is no spire to draw the eye upward.

The front facade is simple; there are Gothic lancet windows without tracery. Set into the windows are panes of modern stained glass. Such simplicity means that the visitor is pleasantly surprised by the richness of detail that lies within.

The interior is a visual feast, with an array of Tudor-Gothic, or Moorish, decorative elements providing a marked contrast to the plainness of the exterior. There is a concave gallery at the back, extending on each side about one-quarter of the way forward along the nave. A Gothic arched ceiling spans the nave, and a false ceiling covers the aisles, intersected at intervals by Tudor arches and drop finials. Blind balustrading provides rhythmic ornamental interest in the design of the gallery. Columns are set on octagonal bases; the shafts are fluted, leading to simple capitals supporting the arches of each bay. On the second level, wooden corbels supporting the arcade arch against the walls. The colour scheme of pale blue, accentuated by a darker blue, serves to delineate the architectural detailing within this church.

The church is situated on a side street within the village, in an unassuming setting.

ST. MARY'S
BIG POND

ST. MARY'S CHURCH AT BIG POND is so typical of Cape Breton church design as to barely attract attention, except for its commanding location high up on the hillside overlooking East Bay. The real beauty of St. Mary's is found inside, where Gothic doors flank the altar and wide arcades rise over the balcony, running along the sides and across the back of the nave. The railings of the balcony are defined by delicate, flat balustrading. The wide pine-planking covering walls and vaulted nave ceiling are original, as are the tongue-and-groove board pews.

ST. PETER AND ST. JOHN ANGLICAN
BADDECK ~ 1883

THE TINY CHURCH OF ST. PETER AND ST. JOHN is almost a textbook study in Gothic revival as it was expressed in North America. The board-and-batten siding, wooden buttresses, and gabled rooflines are right out of Andrew Jackson Downing's publications on cottage architecture, considered suitable for a wide range of modest buildings, from small churches to simple country houses.

The charm of a structure such as this little place of worship in Baddeck is in its delight in the unnecessary. While heavy buttressing was essential for the support of walls in the case of a medieval stone cathedral, it is almost comically superfluous in a miniscule wooden church in a Canadian village. An endless variety of angular movements —in rooflines, gables, pseudo-buttresses, Gothic windows and louvred openings— imbues the structure with a playfulness almost at odds with the solemnity of its purpose.

There are pre-Gothic themes, as well. The "Rhenish-helm" half-roof on the tower is unusual in Atlantic Canada and gives the tiny church an appearance similar to a number of English country churches, notably the eleventh-century Church of St. Mary at Sompting in West Sussex. In England this particular form can be seen as an even earlier adaptation of a German design motif of pre-Conquest origin. Its appearance on a rural Cape Breton wooden church indicates something of the enormously eclectic nature of late nineteenth-century vernacular architecture in Canada.

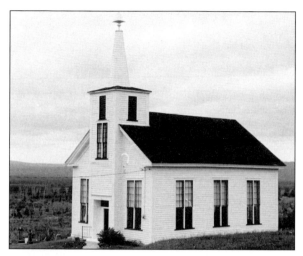

Princeville United

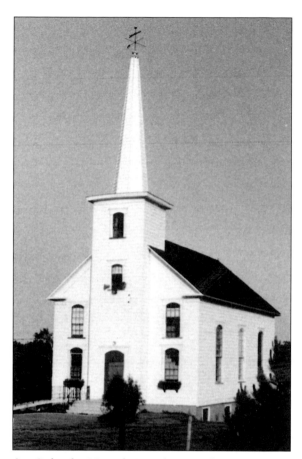

St. Columba United, Leitches Creek

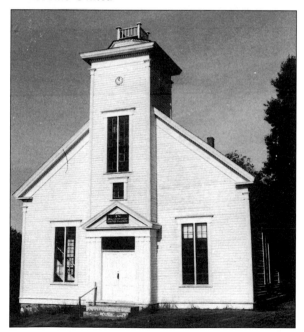

Malagawatch United

ST. COLUMBA UNITED

LEITCHES CREEK ~ *1850*

ONSTRUCTED IN 1850, ST. COLUMBA UNITED was originally built to serve Presbyterian settlers and became part of the United Church with the merger of 1925. It is one of two churches on the Island named for this saint (the other is located at Marion Bridge). St. Columba (c. 521–597) was born at County Donegal and died on the island of Iona, and so is equally revered in Ireland and Scotland. He founded monasteries at Derry and Durrow in Ireland before travelling in 563 to Iona, off the coast of Scotland. The Iona connection is maintained in Cape Breton with the settlement of a village by this place name and by the establishment of St. Columba Church. From Iona, St. Columba preached among the Picts, establishing a monastery also at Lindisfarne. It is reported that St. Columba, whose feast day is June 9, died after copying out from the Psalms, "They that love the Lord shall lack no good thing."

Stylistically, St. Columba is Georgian in sentiment, with returned eaves, a square tower and low, round-arched windows. In fact it is the use of simple carved plank lintels that gives the impression of round-headed windows. Unlike the facade at St. Mary's, East Bay, the facade surrounding the tower here is fenestrated. The west-facing front is treated as a two-storey structure with two rows of windows, while the sides have only one row of tall windows, giving them a single-storey appearance. The interior balcony over the entry does not extend forward, thereby eliminating the necessity for double rows of windows. The spire is set directly and awkwardly on the tower, without benefit of a stepped-down or tapered midsection to provide transition. Despite these awkward expressions of detail, St. Columba is impressive in its architectural lines and harmonious proportions.

PRINCEVILLE UNITED CHURCH
PRINCEVILLE ~ 1864

THE LITTLE CHURCH AT PRINCEVILLE, refurbished in 1883, is one of a handful of straightforward neoclassical houses of worship on Cape Breton Island (others are found at Malagawatch, Forks Baddeck and Big Intervale).

A simple tower, set deeply into the church structure so that there is little forward extension, reinforces the existing of lines and squares. Three openings in the tower—all rectangular rather than rounded or pointed—include a recessed door, over which is set a vertical double-sash window, and above that, a louvred rectangular opening. The spacing of these elements is awkward, with the louvred opening actually resting upon the window in the second level.

Similarly awkward is the absence of a transition from tower to spire; an octagonal spire is planted directly upon the flat roof of the tower, its thin lines juxtaposing somewhat uncomfortably with the heaviness of the understructure.

The front of this little church is striking despite these compositional problems. Especially impressive are the tall, rectangular windows, arranged in pairs, each section of which has an eight-over-six arrangement of small panes. This feature is carried through on a reduced scale even in the smaller windows in the tower, maintaining the same pleasing proportions as elsewhere on the front, back and sides of the church.

The interior is very plain, with tongue-and-groove wooden pews, and plastered walls above wainscotting. The generous windows fill the room with an abundance of light from all sides and open up the church to the surrounding hills and the pleasantly wooded valley over which the church looks.

Built as a kirk for a Presbyterian following, a shift in theology saw it become a church for the more liberal wing that joined the merger with Methodists and others to form the United Church of Canada in 1925. Although the location of the building today is somewhat out-of-the-way, it was once more accessible when the old road wound up the hill and passed directly in front of the church.

MALAGAWATCH UNITED
MALAGAWATCH ~ *1874*

MALAGAWATCH UNITED HAS A STYLE that is neoclassical, suggestive of the Greek temple form. In this regard it has stylistic kinship with Princeville United and with St. Andrew's Presbyterian at Forks Baddeck. Classical-revival elements include returned eaves, a pediment above the door, and corner pilasters. The dimensions of the tower are similar to those at Princeville, and the two towers are set deeply into the church structure, resulting in a shallow front projection. The entrance at Malagawatch takes the neoclassical a step further by employing a triangular pediment above the transom instead of a heavy horizontal architrave as at Princeville. Flanking the door are sets of triple pilasters and capitals. Unlike Princeville, with its crowded arrangement of three openings in its short tower, Malagawatch shows more restraint; its builders inserted only two principal openings (ignoring a tiny square window just over the pediment). The double doorway and paired tall rectangular windows are identical to those at Princeville. The resulting greater leftover space allows for the placement of a false clock at the third-storey level, its painted time frozen at eleven o'clock. Such painted clocks are found on a few Cape Breton churches—notably Union Presbyterian at Albert River and St. Margaret's at Broad Cove.

Where the Princeville square tower is somewhat anachronistically surmounted by a slender spire, the tower at Malagawatch is capped by a low, octagonal dais and railing, creating in effect a belvedere.

While details differ, the essential structures of Princeville and Malagawatch are so similar as to suggest that one was copied from the other, which would seem to make Malagawatch the imitator, since it was built ten years after Princeville. However, Princeville underwent some form of refurbishment in 1883 (nine years after the construction of Malagawatch), possibly either bringing some features more in line with Malagawatch or, alternatively, defining a stylistic departure, particularly if it was at this time that the spire was added (perhaps replacing a belvedere like that at Malagawatch). One cannot help but note the striking similarities even today—three sets of paired windows on both sides of each church, the arrangement of eight-over-six

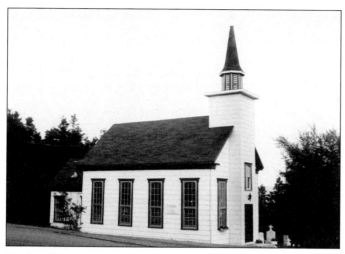

St. Joachim, South Side Boularderie

St. Joachim, window detail, neoclassical

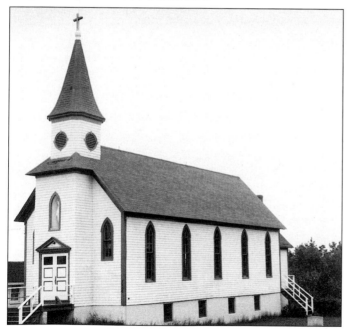

Incarnation, Edwardsville

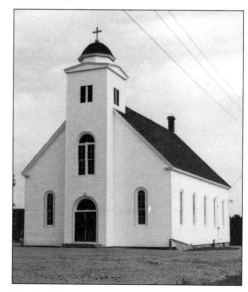

St. Margaret's, West Bay Road

glazing (otherwise unknown in Cape Breton), the short and deeply inset towers, and the general arrangement of neoclassical doorways, pilasters and lintels. The presence of dentils under eaves and pilasters at Malagawatch may seem a deviation from the simpler statement at Princeville, but even this apparent difference may reflect changes made during the 1883 alterations.

The church at Malagawatch is situated parallel to the road, its entrance facing west and overlooking a small bay on the south side of the River Denys Basin.

ST. JOACHIM
SOUTH SIDE BOULARDERIE ~ *1879*

ESTABLISHED AS A MISSION CHURCH of St. Andrew's, Boisdale, the tiny church of St. Joachim was erected at South Side Boularderie in 1879.

St. Joachim is among a handful of Cape Breton wooden churches that were clearly conceived in neoclassical style and, apart from its delicate spire, it yields little to the temptation of the Gothic revival.

Four rectangular openings provide internal variation within the simple facade of square tower and flanking sides. The two windows on each side of the tower are, like those along the sides, remarkably tall for such a small structure, exceeding the size of the door, over which is situated a small double-sash window.

Neoclassical details include returned eaves and rectangular windows with simple lintels. The interior is exceptionally bright, with windows reaching upward to the edge of the gently barrel-vaulted ceiling. The sanctuary is shallow, and its arched ceiling has a nearly semicircular curvature that is a more pronounced counterpart to the flatter curve of the nave ceiling. The interior walls are constructed of horizontal planking, while narrower tongue-and-groove boards are used in the vaulted ceiling. A tiny balcony with pleasingly curved balustrades extends forward over the inner door.

St. Joachim Church lies parallel to the road and the shoreline of St. Andrews Channel, with its sanctuary at the northeast side.

INCARNATION

EDWARDSVILLE

T HIS CHURCH of comparatively recent construction is eclectic in style. Its nar-
row pointed windows are Gothic revival, and from the side create an appear-
ance little different from many Nova Scotia wooden churches of the late
nineteenth century. The front view is another matter: here, three Gothic openings
(two windows flanking a central niche) are somewhat out of keeping with the more
solemn classical mood established by the triangular pediment over the doorway and
the rigidly rectangular geometry of panels on doors and circular venting on the tower.
This rectangularity has been softened by chamfered corners on the tower and spire, a
chamfering that is finely tapered as the spire narrows from bottom to top. The paint-
ing of this structure in two colours (green trim against white background) emphasizes
the framework of vertical corner posts against the horizontal cladding.

ST. MARGARET'S

WEST BAY ROAD

A NOTHER OF THE CHURCHES named for the patron saint of Scotland, St.
Margaret's lies at the intersection of two roads just below West Bay on the Bras
d'Or lakes. Its style is that of Romanesque revival, without any of the conces-
sions to the Gothic style found elsewhere on the side walls of other churches.

The tower is three-storeyed, containing a round-arch doorway with double doors,
enclosed within continuous chamfered moulding. Above, on the second level, is a
window opening that, with its half-round transom, mirrors the opening for the door-
way at the first level. At the top, paired rectangular louvred openings are placed on
each side of the tower. An extremely shallow gabled room, rather small to be called a
pediment, caps the the tower on four sides. At the top, in the absence of a spire, is an
octagonal lantern with ogee-curved roof.

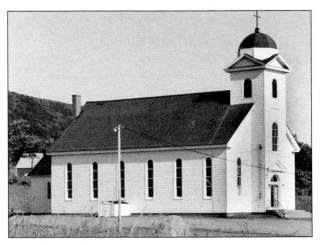

Stella Maris, Creignish

Stella Maris, Romanesque

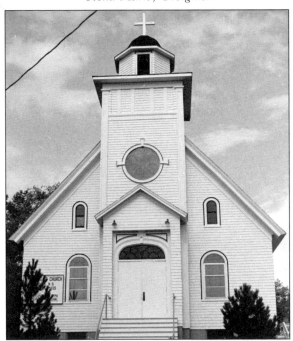

St. Michael's, Baddeck

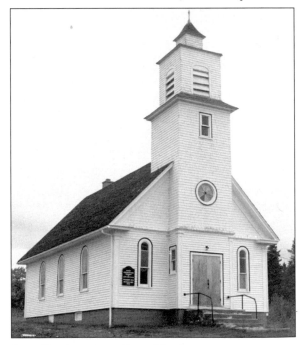

First Presbyterian, Cape North

A neoclassical element is evident in the returned eaves of the roof and the low gables on the tower. Round-headed windows are spaced at five points along the sides, like those at Glendale, where five windows are similarly placed, but there they are pointedly Gothic in structure, in contrast to the more serene Romanesque rounded-ness of St. Margaret's, West Bay.

STELLA MARIS

CREIGNISH

STELLA MARIS (Star of the Sea) is the honourary title in medieval piety for the Virgin Mary as an image of comfort and protection. The name is an apt one for Cape Breton oceanside churches, and it occurs in three places—at Louisbourg on the east side of the Island, and at Creignish and Inverness on the west side.

The style of this small church is highly mixed, with a blend of neoclassical and Romanesque elements predominating.

The square tower here projects only slightly into the structure of the church. Its three storeys are punctuated by three round-headed openings: a door with rounded transom, a round-arched sash window, and a rounded louvred opening. A triangular pediment, with heavy mouldings on all three sides, caps all four sides of the tower, over which is placed a short, octagonal lantern with an umbrella-like roof. These elements as well as returned eaves give a neoclassical air to the facade of Stella Maris. In addition, the double-door entrance is itself set within an outer framework comprised of a classical triangular pediment supported by pilasters that end in flat bases and built-up square capitals. Round-headed sash windows flank the tower, and six larger versions of these, placed at close intervals, run the distance of each side wall.

Stella Maris has a commanding position high on a hill overlooking St. Georges Bay, which separates southwest Cape Breton from the mainland.

A small structure with an immense Gothic window is located behind the main church. Known today as the Rankin Memorial, it may have originally been a vestry or other part of the first place of worship at Creignish, known as St. James.

St. Michael's
Baddeck

THE HEAVILY PROTESTANT makeup of the settlement at Baddeck precluded initial establishment of a Roman Catholic congregation in this picturesque waterfront village. A small Catholic church was erected here as early as 1858–60, but the present structure may be of later construction.

St. Michael's is one of several places of worship built along Romanesque rather than Gothic lines. There are no pointed arches here, no buttresses, no soaring spires. The spirit of this tiny house of worship is one of serenity, conveyed by the simplicity of the half-circle and by the restraint of the flattened curve of the portal. Some neo-classical influences, also of a stabilizing nature, are also found, here manifested in the circular tower-window with keystones at three points, and flat pilasters at the corners of the square tower. Instead of the upwardly thrusting slender spire as at St. Mary's, Mabou, and nearby Greenwood United, a short octagonal lantern with an ogee roof above caps St. Michael's. A small, gabled portico recalls the early practice in which a narthex provided a sheltered transition in front of the church portal. The rustic enclosure at St. Michael's calls to mind a more elaborate counterpart at St. John the Baptist Church in Brook Village.

First Presbyterian
Cape North

THIS SMALL CHURCH, first encountered as one ascends a steep hill en route to Cape North, makes a dramatic impression upon the visitor approaching from the south. When the original Presbyterian Church joined with Methodists and others in the merger of 1925, that structure was renamed Cape North United. In later years the remaining Presbyterian adherents who did not wish to amalgamate undertook construction of a new building nearby.

The new structure is of pleasing proportions, with a handsome square tower stepped back in three stages. While the returned eaves and corner pilasters are of neoclassical formulation, a decidedly Romanesque spirit lingers here in the round-headed windows and louvred opening in the tower.

ST. JOHN THE BAPTIST
BROOK VILLAGE ~ *1939*

THE LATE DATE OF CONSTRUCTION of St. John the Baptist Church at Brook Village does not take away from its architectural interest. Styistically, the design of this modest church is a throwback to an earlier period than that emulated in nineteenth-century church-building, for it recalls not the Gothic but rather the Romanesque form. It is not the pointed Gothic style but the Romanesque round-arch format that predominates here, expressed in double-window groupings.

Rural church architecture is rarely pure in revival of earlier styles, and St. John the Baptist is a good example of the tendency to combine forms within one undertaking. The builders of this church listened to the echoes of the Renaissance as well as the Romanesque. These more sumptuous Renaissance overtones can be seen in the round-arch door, set within a deeply articulated panelled doorway. The most conspic-uous Renaissance allusion is the formal porch, comprised of a triangular pediment set upon fluted columns and elaborate Ionic capitals. The Renaissance reiteration of the architectural forms of Greece and Rome is seen in the complexly built-up mouldings of the pediment and the rows of dentils within the gable and along the architrave of the porch.

The mixture of influences does not stop here, however. Against the cold formality of Renaissance design is the free-spirited element of folk art, manifested in the carved figure of the Paschal Lamb set within the pediment, very likely the work of a local woodcarver.

ST. JOSEPH'S
LITTLE BRAS D'OR

IN THE BROAD, TWO-TOWERED DESIGN of St. Joseph's at Little Bras d'Or we find the attempt to emulate in wood what in the French Gothic Middle Ages was so daringly achieved in stone. The monumental appearance of St. Joseph's is particularly pronounced from a distance, where shortcuts and simplifications of detail are not so easily noticed. As one comes closer, the appearance of complexity gives way to the reality of severity and rustic simplicity of construction.

Within the limits of funds and local craftwork, St. Joseph's is a good example of the popularity of neo-Gothic as the preferred Roman Catholic architectural style of the late nineteenth century in Canada, echoing the revival of this style in France through the work of the engineer Viollet-le-Duc (1814–79). The Gothic style gained tremendous popularity as the result of the appearance of his *Dictionnaire raisonne de l'architecture francaise* (published 1854–68) and his extensive restoration projects of cathedrals and other medieval structures from the 1840s to the time of his death nearly four decades later. His influence was to be felt throughout Europe and in areas of Roman Catholic settlement in the United States and Canada.

The flanking square towers of St. Joseph's are attractively conceptualized, each comprised of four storeys, with the upper levels set back from those below. A particularly pleasing device is the vertical arrangement of Gothic windows and or louvred openings—from the comparative massive character of a single window at the bottom level, diminishing in size from bottom to top, arranged in groupings of one, two, three and four. This reduction in the width of windows from lower to upper levels imparts a strong sense of verticality to what would otherwise be rigidly rectangular towers. The tapering is further realized by the placement of slender pinnacles at each corner. Also very "French" in appearance is the division of the entryway into three portals, each with pointed Gothic arches.

St. Joseph's is an unusually long church, with seven Gothic lancets along each side, and a sacristy that extends behind the sanctuary. Entrance to the church is through the west facade. The hill behind the church rises steeply and contains the parish cemetery.

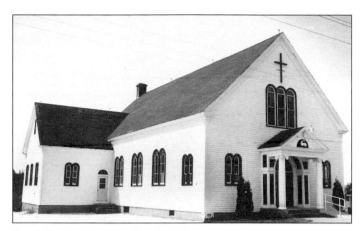

St. John the Baptist, Brook Village

St. John the Baptist, carved detail

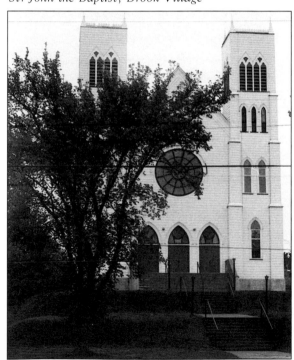

St. Joseph's, Little Bras d'Or

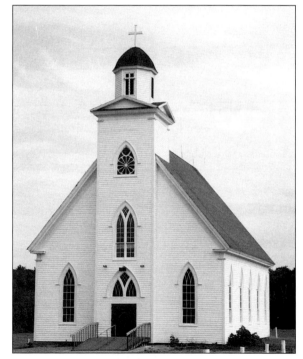

St. Mary's and All Angels, Glendale

St. Mary's and All Angels
Glendale ~ *1877*

S
T. MARY'S AND ALL ANGELS was built in 1876–77 (the first Mass was celebrated in the church in 1877). This attractive church in southwest Cape Breton is a good representative of eclecticism in architecture, amalgamating as it does neoclassical and Gothic elements.

The tower is three-storeyed and is set almost entirely within the structure of the church itself. Above the double-door entrance is a tall Gothic transom with interlacing tracery creating two internal lancets. Surrounding the transom is a strong hood-moulding terminating in perpendicular outward flares. The second storey is marked by a double-lancet Gothic sash window, with eight-over-six glazing. It is enclosed within continuous flat mouldings, and the upper section framed within well-articulated hood-moulding. Into the third storey is cut a small, perhaps overly compressed Gothic window, within which a twelve-spoke wheel has been set, and above that, within the point of the arch, a carved quatrefoil. A similar wheel is seen in the Gothic window of the nearby church of St. Dionysius at River Denys Station.

The tower takes on a neoclassical appearance at its top, where triangular pediments are placed at each side of the roof. The tower is capped by an octagonal lantern with square louvred openings on the four sides. The design of this pedimented tower and octagonal lantern with a low canopied dome can also be seen at the church of St. Mary's, Broad Cove.

As is the case with many churches that have in recent years been sheathed in aluminum siding, it is not clear what was the original exterior covering on the church at Glendale, nor is there any certainty about architectural details such as mouldings and pilasters. It appears here that simple vertical pilasters connect simple bases at the corners to small low-relief capitals beneath the returned eaves of the roof.

The purest Gothic-revival detailing at Glendale is visible on the sides and in the interior of the church. Five tall, pointed Gothic windows along the sides are notable for their three vertical rows of panes and interlacing tracery, which give them a remarkable gracefulness. With a nine-over-six arrangement of glass panes, these tall

windows accentuate the vertical thrust of the steeply pitched roof, creating a lofty effect quite different from that at St. Joseph's, Petit-de-Grat, where there are more windows (eight) at closer intervals, set against a lower-pitched roof with a protruding and hence more prominent neoclassical tower.

The interior is given strong Gothic accents, especially in the unusual manner by which the sanctuary as well as the flanking doors to the sacristy are enclosed within deep, Gothic-arch niches. The interior is covered by a high vaulted roof with ribbing arising from corbels on the upper reaches of piers. Balustered galleries run along the full length of the sides and across the back, and rows of square piers, from floor to arches below the vaulted roof, divide the church into a threefold arrangement of nave and flanking aisles. Much of the wooden Gothic altar remains, as do the original tongue-and-groove wooden pews. A warm interior glow is imparted by the colour scheme of cream with white and pale blue accents.

St. Mary's and All Angels is set in an open field, perpendicular to the road, facing east. A very prominent and attractive landmark, it is visible from a considerable distance to the traveller coming over hills from either the north or south.

ST. DIONYSIUS
RIVER DENYS STATION

THE NOTION OF "WHEEL" WINDOW is taken almost literally here, with the construction of a circular spoked framework that has been set inside the Gothic window of the tower. This ingenuous idea was used twice in Cape Breton, the other example being the window inserted into the tower of the church of St. Mary and All Angels at Glendale.

There are two notable saints bearing the name Dionysius. One was Dionysius of Alexandria (feast day November 17), a pupil of Origen. During times of Roman persecution, he directed his church from a hiding-place in the Libyan desert. Another Dionysius, popularly regarded as patron saint of France, is known more commonly by his French name, St. Denis (feast day October 9). He, too, was the victim of persecution, having been put to death around 258 A.D. at that place in Paris known today as Montmartre (Hill of Martyrs).

St. Joseph's

Glencoe Mills ~ *Circa 1873*

UNLIKE MANY CAPE BRETON churches, which are located alongside a lake, the ocean, or at least a river, St. Joseph's is remote from such natural water-settings. At one time there was a substantial settlement in this area of the upper reaches of the Mull River, and it is known today as the site of the longest-lasting old-style family square-dance, with participants coming all summer from Sydney, Halifax and elsewhere. For the uninitiated vistor, travelling to this place of worship is something of an arduous pilgrimage, following poorly marked inland gravel roads that lead away from the small villages of the coast, through the almost uninhabited rising woodlands on the way toward River Denys Mountain in the interior. The effort is generously rewarded.

Many wooden churches in the region have a central tower, but no other Cape Breton church can boast a bellcote. This feature consists of an arched opening designed so that the bells contained therein are not only heard but seen. The tower is, for that reason, very shallow from front to back. From the front, the tower exhibits a number of similarities to other churches on the Island. The triple-lancet window over the entrance is echoed by a similar structure at Farquharson Memorial in Middle River, while the transom with a grouping of four quatrefoils has counterparts at St. Mary's, Mabou, and St. Mark's Presbyterian, Big Bras d'Or.

The interior of St. Joseph's is largely unspoiled, with its boarded-wall construction intact, including traces of early stencilled trefoil arcade-motif visible behind the Gothic altar. A barrel-vaulted central ceiling, resting on rows of columns, creates the effect of a three-bay nave. Recent modernization has included the replacement of side windows with modern equivalents, an improvement for the heating of the church, but diminishing the pleasure afforded by the Gothic-traceried originals.

An ancient spiritual idea is preserved by the situation of the church within the burial ground; as visitors pass through the cemetery on their way into the church, they are reminded of the Christian notion of the larger community of the living and the dead.

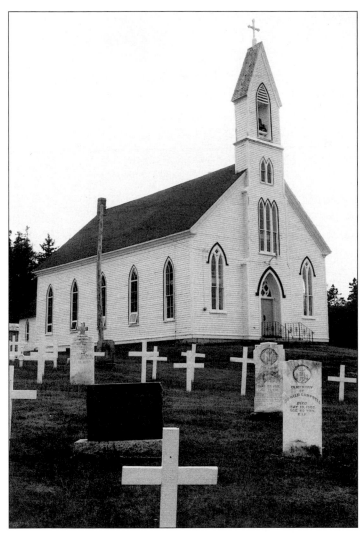

St. Joseph's, Glencoe Mills

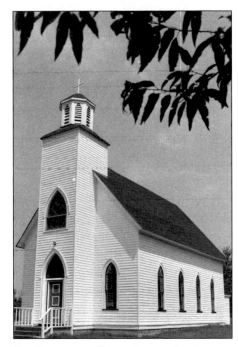

St. Dionysius, River Denys Station

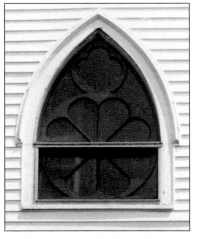

St. Dionysius, wheel window

ST. MARGARET'S

ST. MARGARET VILLAGE ~ *1915*

THE CHURCH OF ST. MARGARET'S at the northernmost extremity of Cape Breton is remarkable in more ways than one. Its dominant position on a high hill establishes its commanding presence and visibility from many directions. It has many exterior details of interest, including the tall spire, flared inward at the base, situated atop a tall, octagonal lantern with louvred openings on all sides. The decorative architectural details of the tower are most distinctive, consisting of an alternation of circular and squared elements. Above the Gothic-style pointed-arch entrance is a moulded lozenge detail, above which is set an octagonal spoked window. At the top of the tower, a square decorative panel is set on its corner to echo the lozenge below. These unusual devices provide an unexpected variation from the usual pointed-arch detailing of Gothic-revival structures elsewhere on the Island.

The real glory of St. Margaret's, however, lies inside. Entering the building from its east doorway, one is led into what can best be compared to the interior of an inverted wooden ship. Like an enormous hull, the ceiling and walls are magnificently sheathed in long boards, steamed, bent and tightly fitted together. The result is the only true half-domed apse in a Cape Breton church, a remarkable achievement in the art of building with wood.

There are as many ingenuous construction features within the church as there are similarly interesting details outside. The impression of a three-aisled interior is conveyed by rows of columns and horizontal beams on each side of the high vaulted ceiling. The columns are cleverly built up to resemble stone cluster-columns of late Romanesque and Gothic architecture. By the placement of half- and quarter-round mouldings around a central square post, a sense of lightness and verticality is created, as was achieved in medieval cathedrals through the transformation of massive shafts into cores surrounded by cluster-columns.

The ancient idea of the church as a ship of salvation, reflected even in the early use of the word "nave" for central aisle or interior, is given outstanding expression in the architecture of St. Margaret's.

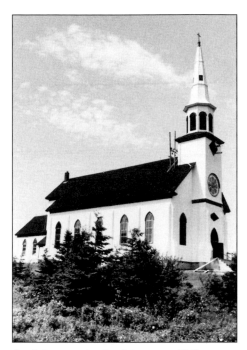

St. Margaret's, St. Margaret Village

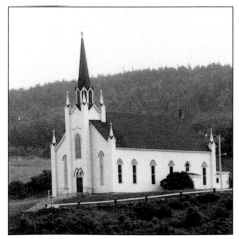

Sacred Heart, Johnstown

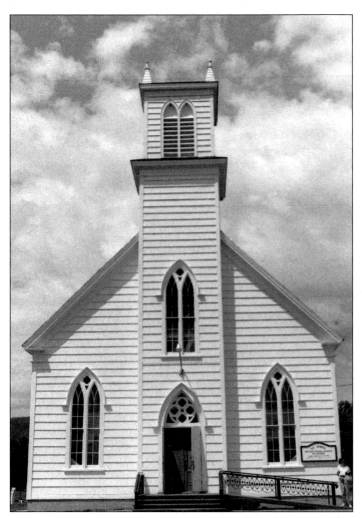

St. James Presbyterian, Big Bras d'Or

SACRED HEART
JOHNSTOWN

ALTHOUGH THE BUILDERS of the road along this stretch of the eastern shore of the Bras d'Or took the easier option of placing it low and along the water, no such concession dampened the determination of the congregation of Sacred Heart Church at Johnstown. When the decision was made to erect a new parish in 1891, it was set high on the hill. Its slender spire and eight cross-crowned pinnacles point toward the heavens, and the placement of the church itself affords a breathtaking view out over the waters below. As an expression of "true pointed Gothick," Sacred Heart bristles with spiky pointiness. Gothic windows flank the doorway, itself topped by a double Gothic arch. Intensifying the upward thrust of Gothic windows is a gabled roof on the tower, Gothic ventilators on the octagonal lantern, and an unusually elongated spire above.

ST. JAMES PRESBYTERIAN
BIG BRAS D'OR

ST. JAMES displays marked similarities with Knox Presbyterian at Ross Ferry, and it would not be surprising to learn that a single builder or designer was involved in the construction of both churches. The proportions are remarkably similar; each has a double-door entrance within a square tower, with lancets above and flanking; in each church there are five Gothic windows along the sides, and the roofline is defined by flat mouldings and returned eaves. There are also interesting similarities to St. Mary's at Mabou, St. Joseph's at Glencoe Mills, and Albert Bridge Presbyterian.

Despite similarities to Knox Presbyterian, St. James makes a quite different statement. Retaining approximately the same characteristic blend of neoclassical and Gothic-revival elements, everything at St. James is rendered more elaborately. Instead of single, tall lancets, windows are complexly designed with double Gothic lancets and a central quatrefoil contained within the larger pointed-arch framework. Rather than a simple tripartite Gothic transom as at Knox Presbyterian, the transom at St. James is an exercise in wooden plate-tracery, with its wheel enclosing four quatrefoils.

The tower of St. James is designed more firmly within the neoclassical idiom, its upper section consisting of a slightly recessed square lantern, with four triangular finials mounted on the four corners of the flat roof. The severity of the earlier style is modified, however, by the placement of double Gothic louvred openings on the four sides.

Like many Cape Breton wooden churches, St. James is beautifully situated, with the water of the Big Bras d'Or behind, beyond which rises majestic Kelly's Mountain.

STRATHLORNE UNITED
STRATHLORNE ~ 1895

BUILT IN 1895, STRATHORNE PREBYTERIAN became Strathlorne United at the time of the merger of 1925.

The setting of this attractive church is truly appealing. Strathlorne United is tucked into a narrow valley on the west side of the Island and can be easily missed from the main road if one does not look carefully up the ravine and through the heavily wooded surroundings.

Strathlorne exhibits strong similarities to Greenwood United in Baddeck, another church built in the 1890s. The resemblances tend more toward decorative detail than to overall architectural conception, but there is much in common between the two structures. Most notable in this regard are the square-panelled square pilasters at the corners and the notion of using applied details for decorative effect. Where Greenwood United used familiar Gothic motifs (quatrefoils, pointed arches), Strathlorne makes use of a simpler geometrical alternative in the form of applied lozenges between door and window sections. Very different from Greenwood's high profile is Strathlorne United's location on the floor of a narrow valley, where some of the most interesting views are those looking down from the hillside directly in front of the church.

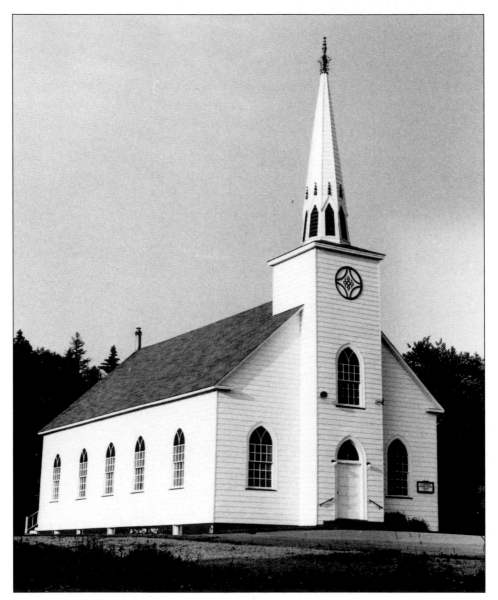

St. Andrew's Presbyterian, North River

St. Andrew's Presbyterian
North River ~ *1873*

VAGUELY REMINISCENT of a popular New England form, St. Andrew's at North River retains the Wren-Gibbs combination of a spire atop a square tower, through which tower a single entrance leads into a spacious hall. Like many Nova Scotia interpretations, it differs from its New England counterparts by the later substitution of the point-arch window for the earlier Georgian rectangular form. Being a product of the later nineteenth century (the church was built in 1873), the windows are of the sliding double-sash type and can be opened.

The spire of St. Andrew's, a finely tapered octagon crowned by a cast-iron finial, is especially pleasing. Accentuating the diminishing perspective of the spire's facets are similarly tapered louvres capped with Carpenter Gothic mouldings. Applied to the front of the tower is an unusual geometric design comprised of an outer circle, ornamented by four joined arcs within.

St. Andrew's is found in a welcoming place—not defiantly posturing atop a hill, but nestled in the valley alongside the North River where the road crosses it on the way to Indian River.

Stewart United
Whycocomagh ~ *1893*

STEWART UNITED, BUILT IN 1893, succeeded the earlier church constructed in 1857 a few miles outside the village. This original structure no longer stands, but its early cemetery is a reminder of the large congregation that once gathered here. The present church was intended to provide mid-week evening services in the village, but eventually became the principal centre of worship for the Whycocomagh Presbyterians. Like many churches, it became a part of the United Church of Canada in the merger of 1925.

Stewart United is a medium-sized structure, neo-Gothic in character, with an impressive square tower and entrance. The pointed-arch windows are accentuated by

heavy rolled mouldings with circular bosses acting as stops. Perhaps the most distinctive architectural detail of Stewart United is the large bell-tower, an open cupola with an ogee-curved canopy above (reminiscent of an umbrella-shaped dome known as a *chatri* in Indian architecture). This imposing structure is itself surmounted by an elaborately filigreed iron finial. A similar ogee-shaped roof caps the tower of Immaculate Conception Church at Barra Head.

ASPY BAY UNITED
ASPY BAY ~ *1842*

THE CHURCH AT ASPY BAY is a curious affair, resulting from the severe alteration of an earlier structure. The original church, built in 1842, is a small Gothic-revival hall. The neoclassical door with its triangular feature is stylistically at odds with the pointed-arch side windows but in keeping with the eave returns, and may have been a part of the first structure. The addition of the square tower at one corner necessitated relocation of the doorway to the other. But neither placement fits comfortably in a building so tiny as this one. The Edwardian double-sash window of the tower and the lozenge window also seem architecturally out of place.

CLEVELAND UNITED
CLEVELAND ~ *1874*

ORIGINALLY CLEVELAND PRESBYTERIAN, this most tiny of churches, located at a quiet crossroads just above the Strait of Canso, was built in 1874. The congregation participated in the great merger of 1925, at which time the church was renamed. Its doorway and windows are in the typical Gothic-revival idiom, while the use of simple diagonals in the louvred opening at the top of the tower represent that short-cut simplification known popularly as Carpenter Gothic.

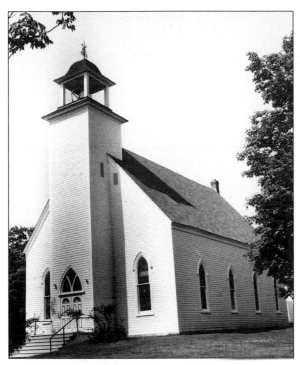

Stewart United, Whycocomagh

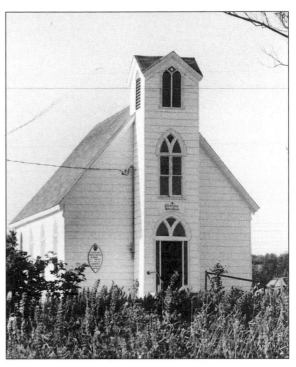

Cleveland United

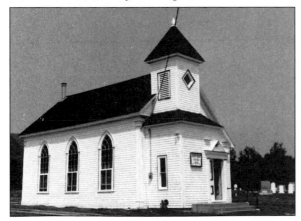

Aspy Bay United

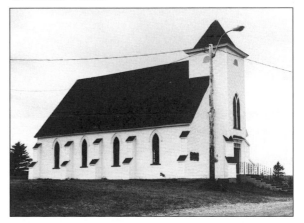

Gabarus United

Gabarus United
Gabarus

U NLIKE CHURCHES such as St. Mary's, East Bay, or Immaculate Conception, West Lake Ainslie, which are vertical in emphasis, Gabarus United is a squat structure, serious and solid. It hunkers down on the lowland at Gabarus Bay. The sturdy spirit of Gabarus United is accentuated by the substitution of a low pyramid for the usual spire over the tower, heavy hood-mouldings around windows, and massive stepped buttresses not only along the sides but also at the corners of the tower flanking the door (for similar treatment, note Wilson United at Margaree Centre). Within this heaviness, however, is an unusual delicacy of detail in the four-fold vertical division of the windows and the resulting refinement of overlapping Gothic bar-tracery.

St. Joseph's
Lingan

S T. JOSEPH'S AT LINGAN bears such close resemblance to St. Rose of Lima Church on the north shore of East Bay as to suggest that not only the design but even the construction of these two structures is the work of the same builder.

Like the tower at St. Rose of Lima, the tower at St. Joseph's is tapered at the centre, providing a transition to the lantern that begins at the level of the upper roofline, rather than above it, as is customary. In both churches, the tower and spire are shingled and a circular window is set above the doorway. Related details are seen throughout and are most clearly evident in the dot-and-bar decorative treatment of moulding boards along the horizontal and diagonal roof-edges.

St. Joseph is uniquely situated, with the enormous Lingan Generating Station located immediately in the background, providing a dramatic juxtaposition of notions of power.

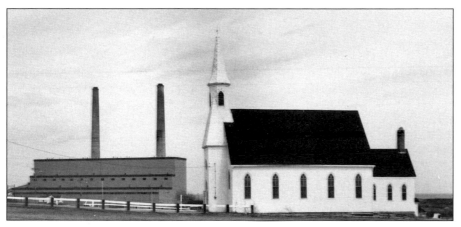

St. Joseph's, Lingan

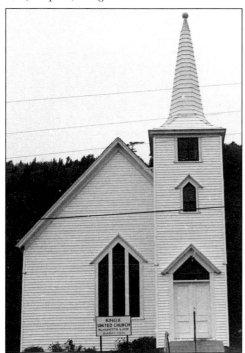

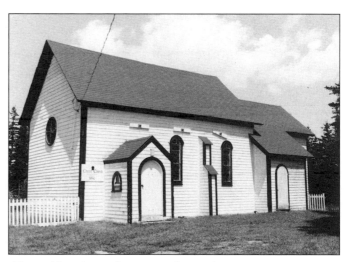

Christ Church Anglican, South Head

Knox United, Blacketts Lake

CHRIST CHURCH ANGLICAN
SOUTH HEAD ~ 1846

THE ANGLICANS OF CAPE BRETON erected a grand stone church at Sydney in 1787, but for the most part they built modest wooden structures such as the charming Christ Church on the peninsula at South Head. Built in 1846, it is one of the oldest wooden churches still in use, although its services have been reduced to only occasional events, most notably a harvest celebration in the fall.

Christ Church Anglican provides an echo of Romanesque parish churches of a much earlier time, reflected in its simple round-headed windows and doors. A circular window is found in the west wall, and separate entrances on the south side open directly into the nave and into the vestry beside the sanctuary at the opposite end. A single stepped-arch provides additional support at the middle of the south wall. Simple geometric stained glass is set into the side windows, a feature that tends to distinguish Anglican church-building on the Island.

KNOX UNITED
BLACKETTS LAKE

THE LITTLE KNOX UNITED CHURCH at Blacketts Lake is a rare manifestation of the Carpenter Gothic style in Cape Breton. The curvature of the traditional pointed arch is replaced by a different kind of pointing, requiring skills within the competence of the local carpenter. The design of Knox United is also a good example of the "Akron Plan," allowing entry to the church through the corner tower.

DRUMMOND MEMORIAL UNITED
BOULARDERIE

LOCATED JUST A SHORT DISTANCE along the road from Ross Ferry, Drummond Memorial United is one of those tiny corner-entrance churches that were popular especially among the Methodists in the late nineteenth century.

Its style is, for lack of more precise terminology, a "Victorian Romanesque," which was favoured in the design of both private homes and public buildings in the final decades of the nineteenth century. In this case, any distinctiveness of style is largely defined by a part—namely, the second storey of the corner tower—rather than the whole. The tiny circular towers at the four corners of the square tower are suggestive of castle architecture, a whimsical design source for many buildings in the late Victorian and Edwardian eras. The insertion of a returned eave halfway along the pitch of the roof where it meets the tower is a bizarre treatment.

In design, this small church has cousins at Skir Dhu and Glen Haven.

GLEN HAVEN UNITED
GLEN HAVEN, SOUTH GUT, ST. ANNS ~ 1927

BUILT IN 1926 OR 1927, just after the Church Union of 1925, this tiny structure is a familiar landmark along the route from Sydney to Baddeck, hidden in the trees in the shallow valley at St. Anns Bay. Glen Haven United has been a popular subject for numerous local painters.

The style of this church is essentially in the spirit of the late Romanesque revival that swept the United States and Canada at the end of the nineteenth century. Its round-headed windows and small tower bear resemblance to the general outlines of Drummond Memorial United on nearby Boularderie Island. The corner tower and entrance follow the "Akron Plan" used in many Protestant churches of the time.

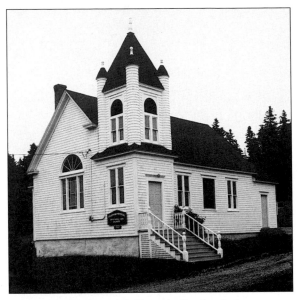

Drummond Memorial United, Boularderie

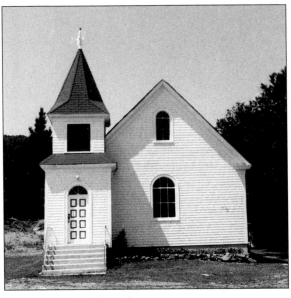

Bethel United, Skir Dhu

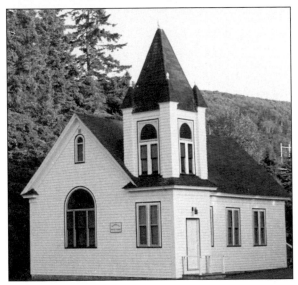

Glen Haven United, South Gut, St. Anns

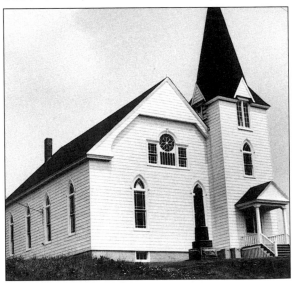

St. Andrew's Presbyterian, Framboise

BETHEL UNITED
SKIR DHU ~ *1926*

ERECTED IN 1926, this diminutive church reflects the "Akron Plan" of church-building of the late nineteenth century with its asymmetrical tower and corner entrance. Simple round-arch windows and door are in keeping with Richardsonian Romanesque architectural design elements that were being used widely in public buildings of the period. The church is next to the road that goes north of Englishtown before it rises sharply into the highlands at Cape Smokey.

ST. ANDREW'S PRESBYTERIAN
FRAMBOISE

ALTHOUGH A MUCH HUMBLER STRUCTURE than nearby Calvin Presbyterian at Drummondville, the church of St. Andrew's at Framboise possesses many similarities to the grander structure overlooking Loch Lomond. It also shares with its larger cousin an unashamed eclecticism of style.

The tower here is not simply ornamental, but serves also as the entrance, making St. Andrew's another of the "Akron Plan" churches in which the entrance was shifted away from the centre of the facade to the corner. The gablets at the base of the octagonal spire and the gabled porch are identical to those at Calvin Presbyterian, suggesting that these churches may be the work of one builder. The use of coloured glass in the windows is also similar to that at Drummondville.

Thoroughly delightful in its variety is the array of stylistic elements comprising the details of the east facade. The neoclassical porch competes with the Gothic fenestration in establishing the atmosphere of a sacred place. Other incongruities include the rectangular Georgian double windows pushed through the roofline of the tower and the Victorian variation of a Palladian three-part window in the upper storey of the church proper.

St. Andrew's faces eastward from the hillside, overlooking an inlet of Framboise Cove.

CALVIN PRESBYTERIAN

DRUMMONDVILLE, LOCH LOMOND ~ 1926

THE INLAND PRESBYTERIANS at Drummondville were determined to make their mark on the landscape when, in 1910, they undertook the construction of their stately temple of worship overlooking Loch Lomond. Not one but two gabled porticoes provide entrance at the corners of the west facade. Ascending the steeply pitched staircases, which already begin at mid-point on the slope up from the roadway, spiritual travellers to Calvin Presbyterian leave the ordinary world behind when arriving for Sunday services.

The architecture of Calvin Presbyterian is vigorously eclectic, and it is the most grandiose of several buildings reflecting a regional building style (other, humbler structures include the nearby Zion United at Gabarus Lake and St. Andrew's at Framboise).

The exceptionally wide west wall is punctuated by two rows of windows, flanked by stepped square towers hinting at distant Norman inspiration, making an incongruous backdrop for the neoclassicism of the porches. Unlike the traditional truncation of Norman towers, there is an upward extension of four-sided spires with gablets around the bases. Window openings are a veritable sampler of architectural styles, including Gothic, Romanesque, and the square type popular in Edwardian houses at the turn of the century.

The south wall is an identical replication of the design of the west facade, conveying a particularly imposing impression to the visitor approaching from the southwest. By contrast, the north wall is a single-storey Gothic facade, mostly undistinguishable from that of the many modest Gothic-revival churches on the Island. The richness of architectural detail at Calvin Presbyterian is echoed in the unusual (by Cape Breton standards) feature of coloured-glass panels in its many windows.

Rarely is the dynamism of natural surroundings and the formalism of architectural traditions so curiously mingled as at this out-of-the-way place in the hilly country around Loch Lomond.

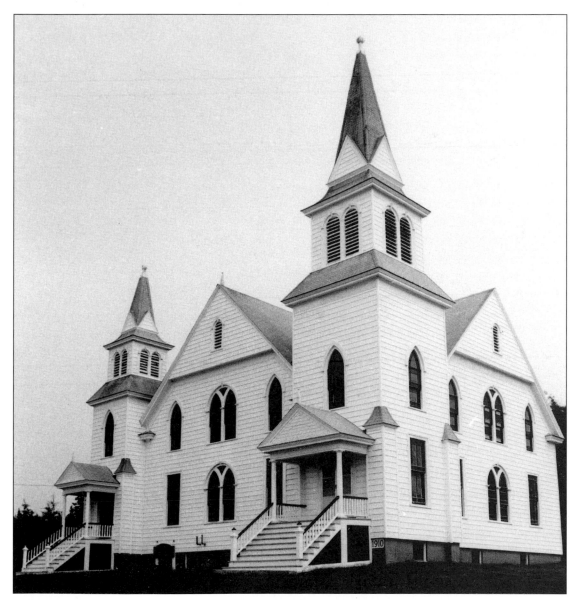

Calvin Presbyterian, Drummondville, Loch Lomond

Princeville United,
Georgian neoclassical

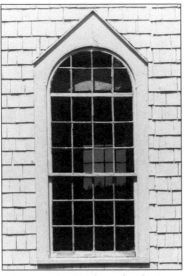

St. Margaret's of Scotland, River
Denys Mountain, Romanesque

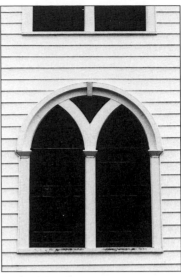

Calvin Presbyterian,
Drummondville, Romanesque

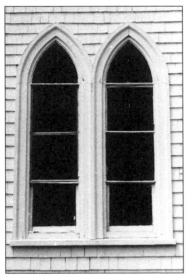

St. Joseph's, Marble Mountain,
Double Gothic

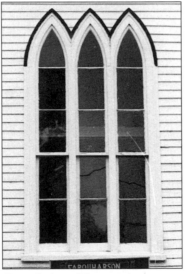

Farquharson Memorial,
Middle River, Triple Gothic

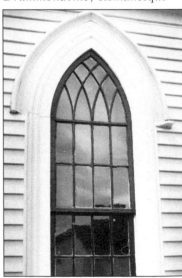

Gabarus United,
Gothic, fan tracery

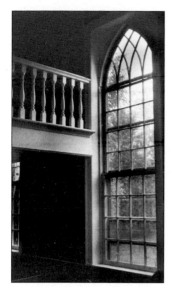

St. Mary's, Frenchvale,
Gothic

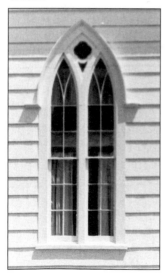

St. James Presbyterian,
Big Bras d'Or, Gothic

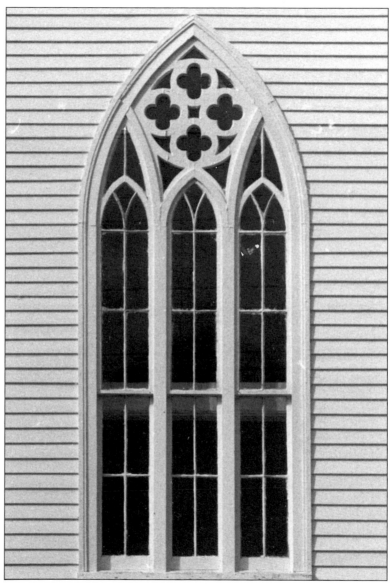

Immaculate Conception, West Lake Ainslie,
tower, Gothic

117

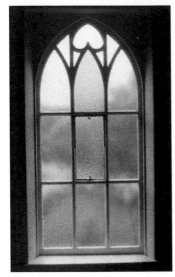

St. Mary's, East Bay,
window with heart, Gothic

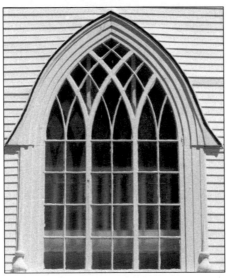

St. Margaret's, Broad Cove,
Gothic

Immaculate Conception,
Barra Head, Gothic

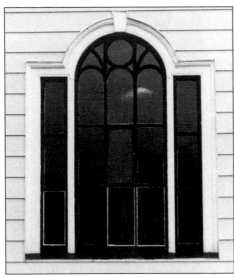

St. Mary's, East Bay,
Palladian

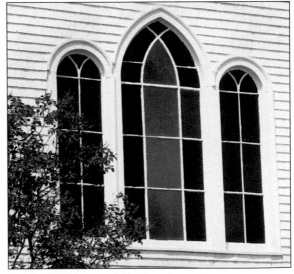

St. Paul's United, Marble Mountain,
Palladian variation

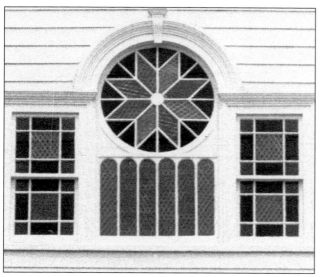

St. Andrew's Presbyterian, Framboise,
Palladian variation

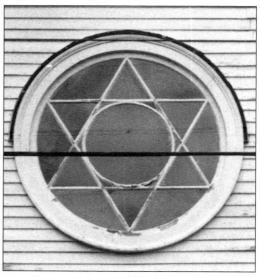

Farquharson Memorial Presbyterian,
Middle River, star

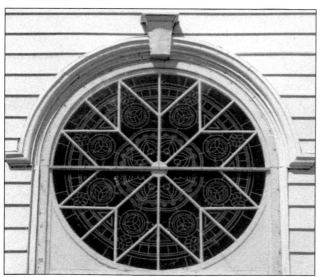

Port Morien United, star

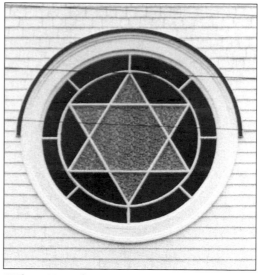

Wilson United, Margaree Centre, star

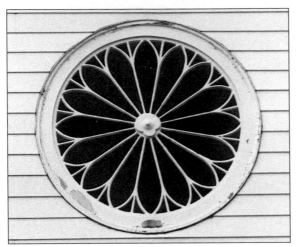

St. David's United, Port Hastings,
sixteen-petalled rosette

St. Patrick's, North East Margaree,
rosette, plate tracery

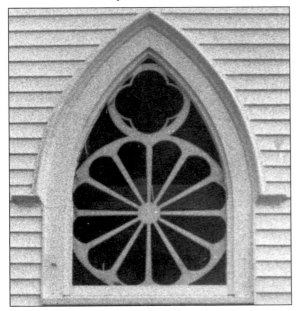

St. Mary's and All Angels, Glendale, wheel

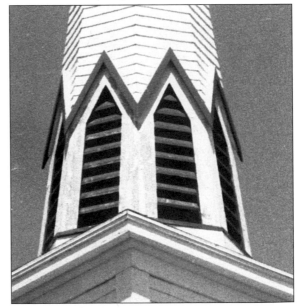

Calvin United, Birch Plain,
Carpenter Gothic louvres

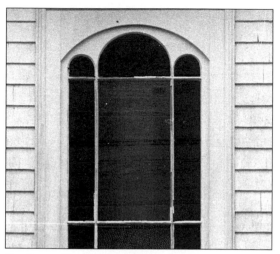

St. James Presbyterian, Catalone,
arcaded

Fourchu United, Fourchu,
arcaded

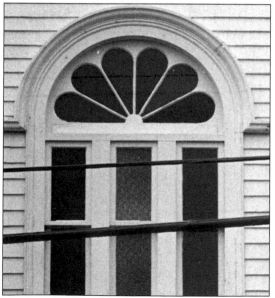

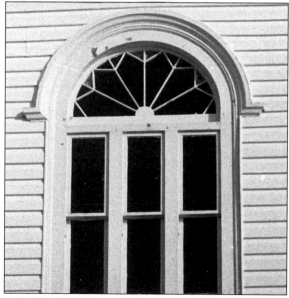

St. James Presbyterian, Catalone,
sunburst tracery

Fourchu United, Fourchu,
sunburst tracery

Union Presbyterian,
painted clock

St. Mary's, East Bay,
stations of the cross

Immaculate Conception, Barra Head,
carved hand

Immaculate Conception, West Lake Ainslie, pew panelling

St. Rose of Lima, angels in railing

GLOSSARY

AKRON PLAN Named for a church design employed in 1870 at Akron, Ohio, the term refers to churches with the entrance placed at one of the corners rather than in the centre of the facade. This floor plan was especially popular among Methodists and Baptists and came to dominate the design of small North American churches in the late nineteenth and early twentieth centuries.

APSE In Roman public buildings and early Christian churches, a projecting niche provided a place of prominence for juridical, political or liturgical activity. In nineteenth-century architecture, the apse sometimes continued this earlier function, or alternatively, it served as a vestry behind the sanctuary proper.

ARCHITRAVE In relationship to the top edge of a door or window, the architrave is the moulded surface extending upward to the frieze, or the wide surface running between it and the cornice. The architrave is the lowest-placed element of the architrave, frieze and cornice, which together comprise an entablature.

BALDACCHINO Also known as a baldachin, the term refers to a canopy placed over the altar or other place of ritual significance. Such honorific canopies are supported variously by suspension from the ceiling or resting upon columns at the four corners. The most illustrious baldacchino in Christendom is the elaborate structure designed by Bernini for St. Peter's in Rome. Modest country churches frequently gave indirect reference to such canopies by simple low-relief framing devices on the wall behind the sanctuary.

BALUSTRADE The structure formed by a series of posts, rounded or flat, arranged in a row between an upper and lower horizontal bar.

BELLCOTE A cote is an enclosure (a dovecote, for example, is a house for birds), hence referring here to a framework designed to house the bell or bells of a church. Bellcotes may take the form of niches or be pierced completely through the tower wall as openings through which bells are visible from both sides. This form particularly popular in churches of Italy and the Spanish New World also found its way into English country churches.

BELVEDERE Meaning "beautiful view," a belvedere may be placed on the ground as a free-standing pavilion or, more characteristically, as a structure on top of a domestic or public building, affording a panoramic view of the surrounding countryside.

BOARD-AND-BATTEN Initially intended as a carpenter's shortcut, board-and-batten construction is comprised of vertical boards arranged side-by-side, with narrower strips nailed in place to cover the joins. The technique, advocated in mid-nineteenth-century manuals, was widely used in construction of wooden cottages, villas and small churches.

BROACH (SPIRE) When a spire is octagonal, it is called a broach spire if it is joined to the tower by triangular or pyramidical elements at the four corners of the tower.

BUTTRESS External supporting member to brace church walls, typically positioned at a diagonal from the ground. This structure is sometimes called a flying buttress. An alternative type of buttress takes the more vertical form of a tower, generally stepped back in stages from lower to higher sections. Because of the increasing height of Gothic churches, external buttressing is particularly associated with that style.

CAPITAL The upper element of a column or pilaster that crowns the shaft, and upon which rests the horizontal lintel or entablature.

CARPENTER GOTHIC As the name implies, this is a style devised not so much for the master craftsperson as for the ordinary, hard-working builder. The curved members traditionally comprising the arch of Gothic windows and portals are replaced by straight elements sloped so as to meet at a raised point at the centre, a simpler and convenient shortcut. English architect Batty Langley (1696–1751) is generally credited with originating the idea in his design books, but the style gained particular popularity in the wooden domestic and church architecture of nineteenth-century North America.

CHAMFER A decorative effect achieved by bevelling the corner of an architectural member or furniture element at an angle (usually 45 degrees).

CLERESTORY Known also as a clearstory, the term refers to that upper stage of church architecture set above the main walls and roof of the side aisles. Normally, the clerestory has windows, and in earlier structures, frequently features a narrow wall-corridor.

CORBEL A block extending outward from a wall, designed to support the base of a beam or rib running upward to the roof.

CORNICE Uppermost member of entablature, the cornice is the moulded projection surmounting the frieze of an architectural or furniture facade.

DENTIL Moulding of small rectangular blocks arranged horizontally in series on architectural cornices. This decorative device, comprised of "teeth" with spaces between, is also used beneath the projections of furniture rendered in architectural manner.

DOWNING, ANDREW JACKSON Known for his interest in natural landscape and rural architecture, Downing (1815–52) wrote essays and produced design books. Especially influential for North American domestic and church architecture of the later nineteenth-century are his *Notes about Buildings in the Country* (1849) and *The Architecture of Country Houses* (1850).

ENTABLATURE The horizontal upper part of an order of architecture supported by columns and consisting of an architrave, frieze and cornice.

FENESTRATION Placement of windows in buildings.

FLUTING Concave grooves used particularly on friezes and columns. In furniture, fluting was part of the neoclassical embellishment of late eighteenth-century domestic design, gradually giving way to a preference for reeding as a means of furniture ornamentation in the early nineteenth century.

GEORGIAN While Georgian architecture is inspired by classical proportions and decorative elements, its expression in North American building represents a great simplification of the style as it had flowered in Great Britain. Retained from the more sumptuous British background are pleasing symmetries of design, notable in the placement of windows, chimneys and other elements. In the United States and Canada, Georgian structures are characterized by modest neoclassical details, including eave returns, pilasters and lintels. Windows are characteristically rectangular or fan-shaped, unlike the pointed arch of the Gothic-revival style.

GOTHIC While the original Gothic architecture of the medieval period feature such elements as the rib vault, pointed arch and flying buttress, its nineteenth-century revival is most commonly characterized by the pointed arch in windows and portals. The revival of Gothic forms became highly fashionable, even in domestic contexts, after Horace Walpole's Strawberry Hill (built c. 1750–70), and in church architecture was closely connected to a wider interest in medievalism.

HOOD MOULDING Mouldings built to enclose the uppermost section of windows or arches were commonly referred to as hood mouldings, suggesting their role in diverting rain from a wall. Some mouldings of this type are of shallow projection, suggesting that their function was more decorative than practical.

KEYSTONE The centremost stone placed at the peak of an arch or rib vault. The term has strong symbolic associations because of its reference to that element without which the remaining structure could not stand.

LANCET A narrow, tall window, usually with Gothic pointed arch, placed sometimes in an arrangement flanked by shorter such windows on each side. Such windows were commonly built in Gothic churches of the thirteenth century and were one of the most common features of the Gothic revival of the nineteenth century.

LANGLEY, BATTY This English architect-designer (1696–1751) produced many architectural books that gained widespread usage by country builders over the next century. Many nineteenth-century Gothic-revival churches in Canada bear significant resemblance to designs found in publications such as Langley's *Gothic Architecture Restored and Improved* (1741) and other works.

LANTERN A small turret-shaped structure set atop a roof or dome, hearkening back to Renaissance designs, but gaining renewed popularity in nineteenth-century architecture through to the Victorian period. Lanterns could be round, square or octagonal, and might be fitted with windows, louvres or open arcading.

MOULDINGS Decorative and sometimes functional projections that follow the shape of windows, portals or arches.

MULLIONS Posts or bars separating glass panels in windows and doors.

NAVE The long central section of a church, running from the entrance to the crossing, and flanked by aisles.

NEOCLASSICAL In contrast to the exuberant and curvilinear character of baroque and rococo design, neoclassicism represents a return to the more restrained lines and balanced proportions of Greek and Roman architecture. Neoclassical structures are more rectangular and symmetrical than their baroque predecessors, and in North American church architecture, severity and simplicity of line are the rule.

OGEE CURVE A curved line with two sections, one curved inward (concave) and the other curved outward (convex).

PALLADIAN WINDOW Associated with designs by the Italian architect Andrea Palladio (1508–80), and popularized in England three-quarters of a century later by Inigo Jones (1573–1652). From Palladio's device of a central arch and flanking openings set off by columns (itself deriving from Sebastiano Serlio and Donato Bramante and a motif known as a Serlian arch), the Palladian window is comprised of three sections, the middle of which is typically arched and taller than the flanking elements. The device was popular in late eighteenth-century Georgian architecture in eastern North America.

PEDIMENT In architecture the term refers to a gable placed above a window, door or portico. Such pediments can be curved or triangular. In vernacular architecture, the feature of a pediment imparts a classical formality to structures otherwise severe and simple in conception.

PICTURESQUE STYLE "Picturesque" buildings are characteristically of asymmetrical design and sometimes of deliberately rusticated texture. In domestic architecture the style was represented in England by the cottage plans and the Gothic country houses of John Nash (1752–1835). Such designs, employed in homes, farm buildings and churches, were disseminated in publications such as Papworth's *Designs for Rural Residences* (1818), and in North America by Andrew Jackson Downing's *The Architecture of Country Houses* (1850).

PIER While the term is more or less interchangeable with pillar, it refers in early contexts to the massive columns that supported arches in Romanesque and Gothic churches. Such piers were round or square, or composite, with attached shafts, also known as a compound pier.

PILASTER In contrast to a free-standing column, a pilaster is shallow and projects only slightly from the wall to which it is attached. Such pilasters might be half-round, fluted or otherwise shaped. They are intended to be seen from the front as columns, with bases and capitals corresponding to the traditional orders.

PORTICO Enclosing the entrance and providing visible grandeur of approach, a portico is a covered space or porch extending forward from the facade of a church or other building of consequence. The structure is usually that of a pediment set upon columns, giving a sense of importance to the place of entry.

PUGIN, AUGUST WELBY A draftsman of French background, Augustus Welby Northmore Pugin (1812–52) edited numerous books on architecture. Following his conversion to Roman Catholicism in 1834, he turned increasingly to Gothic architecture, and in 1841 he wrote his major treatise, *The True Principles of Pointed or Christian Architecture*. He designed many churches, and his ideas on Gothic style influenced builders and designers in Great Britain and North America throughout the second half of the nineteenth century.

QUATREFOIL A design of four leaf-shaped curves enclosed within a circular framework, frequently set into the space between arched sections in windows, door transoms, and archways. Alternative numbers of foils (leaves) are described by terms such as trefoil and multifoil.

RHENISH HELM The term is used in reference to a spire comprised of four sides, joined at the top and featuring a gable in the foot of each side.

RENAISSANCE In the present context, the term is used in connection with nineteenth- and twentieth-century churches that, in spite of their simplicity of style and construction, make use of some of the rich architectural detailing reminiscent of sixteenth-century Italian architecture. Among such references are porticoes, pediments, elaborate framing of external and internal doors, and complexly designed columns and pilasters.

RICHARDSON, HENRY HOBSON The American builder and designer Henry Hobson Richardson (1838–86), following studies at Harvard and the Ecole des Beaux Arts in Paris, developed a heavy Romanesque style for churches, public buildings and large homes. He influenced designers such as McKim and White, Root, and Sullivan, and his designs were greatly lightened and simplified in the construction of wooden churches and other buildings into the twentieth century.

ROMANESQUE A heavy architectural style of debated origin, but preceding the taller and lighter Gothic style, Romanesque design is characterized by round arches (a necessity of engineering methods of the time). The use of the round arch as a decorative feature is seen in nineteenth- and twentieth-century churches using round-headed windows, doors and arches, and in the preference for the dome shape to the pinnacle in roof design and the round arch to the pointed arch in vault design.

RUSKIN, JOHN The essayist John Ruskin (1819–1900) had immense influence upon the shape of architecture in the nineteenth century, although he was not an architect by profession. His ideas were based more upon philosophies of the spirit than upon engineering considerations, and his essay "On the Nature of the Gothic" argued for an intrinsic connection between the beauty of medieval building style and the spiritual fulfilment experienced by those engaged in the act of design and building. Like Pugin and others, Ruskin contributed to the nineteenth-century view that the Gothic was the proper style for church building.

SACRISTY The room adjacent to the sanctuary for storage of sacred vessels, vestments and articles used in the Christian liturgy. The sacristy is known also by the term vestry, referring to its setting in which the celebrants dress in preparation for the liturgical service.

SANCTUARY The sacred place in the church where the altar is situated and in which the public celebration of the liturgy takes place. As the place of the Holy of Holies, the sanctuary (sometimes known as the presbytery) is approached with special reverence and is set apart from the remainder of the church building by railings, screens, steps or other visible architectural thresholds.

SOUNDING BOARD The acoustic canopy set above the pulpit to facilitate projection of the word, spoken or read at liturgical celebrations. Pulpits and sounding boards became increasingly popular in the later Middle Ages as greater emphasis was placed upon preaching and sermonizing. In New England, the pulpit became the centrepiece of Congregational and other Protestant churches, and that central function is retained in some early structures in Maritime Canada.

STOP A projecting element at the end of a hood moulding, usually running perpendicular to the moulding element. Such stops are usually horizontal, but sometimes are designed alternatively as curves or bosses.

TRACERY Decorative design in windows achieved by stone or wooden bars, carved or shaped to produce patternwork. When such ornamental effect is achieved by arrangement of bars or mullions, it is known as bar tracery; when accomplished by the carving of motifs through solid stone or wood, it is defined as plate tracery.

TRANSOM From Latin *transtrum*, indicating a crossbeam, a transom is any horizontal piece in a structure, usually taking the form of a window, opening or recessed space above a door.

TREFOIL A design of three leaf-shaped curves enclosed within a framework, frequently set into the space between arched sections in windows, door transoms and archways. Alternative numbers of foils (leaves) are described by terms such as quatrefoil and multifoil.

"TRUE POINTED GOTHICK" A moral catchphrase from the writings of Augustus Welby Northmore Pugin (1812–52), who argued for the spiritual superiority of Gothic architecture in the construction of new church buildings in the nineteenth century. He was particularly attracted to the English decorated style, the fine proportions and richness of detail of which provided the basis of the phrase.

TUDOR ARCH Sometimes called "Moorish," the Tudor arch is a somewhat flattened variant of the pointed Gothic arch, with the distinctive feature of an ogee curve defining each side of the arch.

VESTRY (see sacristy)

VIOLLET-LE-DUC, EUGENE EMANUEL The French engineer Viollet-le-Duc (1814–79) was interested in the possibilities of preservation and restoration of medieval buildings. His first project was the restoration of the great church at Vezelay. He is best known for his interest in Gothic architecture, a style that regained tremendous popularity with the publication of his *Dictionnaire raisonne de l'architecture francaise* (published 1854–68), and his extensive restoration projects of cathedrals and other medieval structures from the 1840s to the time of his death nearly four decades later. His influence was to be felt throughout Europe and in areas of Roman Catholic settlement in the United States and Canada.

INDEX OF PHOTOGRAPHS